IMAGES
of America

MIDDLETOWN

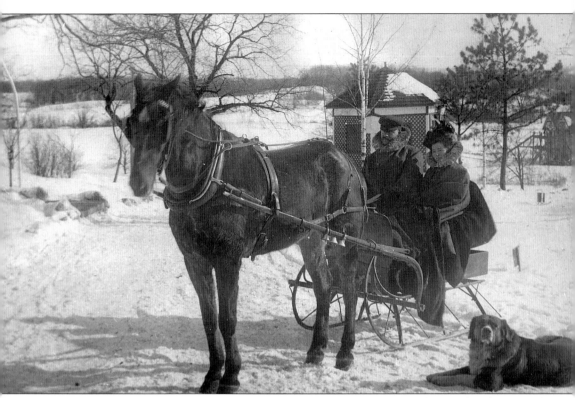

A well-muffled couple heads out for a sleigh ride in the country, one of the simpler pleasures of life in the "good old days."

IMAGES
of America

MIDDLETOWN

Marvin H. Cohen

ARCADIA

Copyright © 2001 by Marvin H. Cohen.
ISBN 0-7385-0866-7

First printed in 2001.

Published by Arcadia Publishing,
an imprint of Tempus Publishing, Inc.
2A Cumberland Street
Charleston, SC 29401

Printed in Great Britain.

Library of Congress Catalog Card Number: 2001089159

For all general information contact Arcadia Publishing at:
Telephone 843-853-2070
Fax 843-853-0044
E-Mail sales@arcadiapublishing.com

For customer service and orders:
Toll-Free 1-888-313-2665

Visit us on the internet at http://www.arcadiapublishing.com

CONTENTS

ACKNOWLEDGMENTS

I wish to thank everyone at the Historical Society of Middletown and the Wallkill Precinct who assisted me with this book. A special thank you goes to Ann P. Vail, whose unparalleled knowledge of Middletown was invaluable.

*This book is dedicated to Charles L. Radzinsky,
artist, historian, gentleman.*

INTRODUCTION

The Historical Society of Middletown and the Wallkill Precinct once published a yearbook, beginning in the year 1953. The 1957 edition focused on the New York, Ontario and Western Railway and was written by Thomas B. Girard. I had known Mr. Girard for many years and, one day, encountering him in the post office, asked how I could obtain a copy of the book. He said, "Give me $2 and I'll sign you up as a member of the historical society." So, of course, I did.

Like many members, I never visited the museum or became active in historical society affairs until a very good friend, Charles L. Radzinsky, encouraged me to come down on Wednesday afternoons, when the building was open to the public. "Rad" was then the curator, and I tried to help out while at the same time staying out of his way—no easy task. When he became ill and later passed away, I was named curator and, shortly thereafter, was elected president of the group.

The Historical Society of Middletown was formed as long ago as 1923, but it was not until 1939 that the beautiful home at 25 East Avenue was donated to the group by Mrs. Edwin Welling Van Duzer. Many historical artifacts repose in its collections, along with an extensive photograph library. Virtually all of the photographs in this book are from the society's archives. Of course, there are many people and homes, businesses and industries, woods and fields of which we have no photographs. Each reader who possesses old photographs of Middletown is encouraged to remember the historical society when disposing of them.

This book is not a complete history of Middletown. It is a compendium of old photographs, which should, at the very least, satisfy the query—"So that's what that building was!" Today's Middletown, although bereft of most of its major industries, is still a vibrant community, located in the heart of Orange County. Now, step back in time and visit the city in these photographs that recall the years from the 1850s to the 1950s.

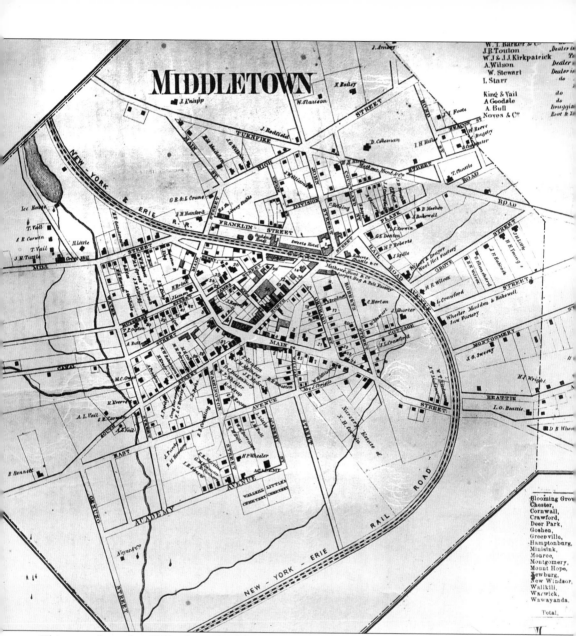

This map from the 1850s shows Middletown as an octagon. Note how the railroad snaked through town.

One
EARLY DAYS

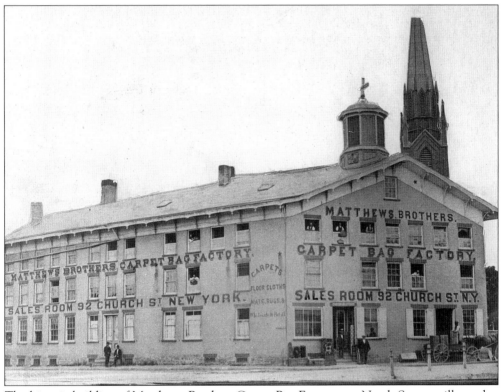

The historic building of Matthews Brothers Carpet Bag Factory, on North Street, still stands and has housed Ayres and Galloway Hardware Company for many years. This photograph dates from c. 1868.

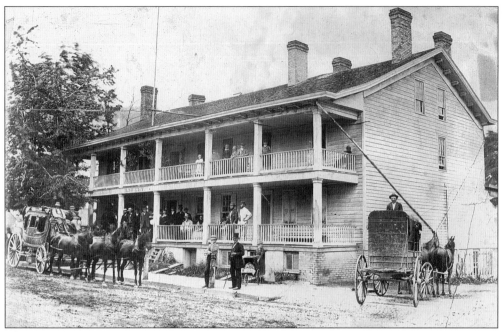

This historical photograph shows Sweet's Hotel in the 1870s. This site was on North Street next to the railroad tracks. The Monticello stagecoach waits in front of the door. The man on the porch in the white hat, just right of the horse's head, is reputed to be famed editor Horace Greeley. The proprietor Halstead Sweet stands just above the horse's ear.

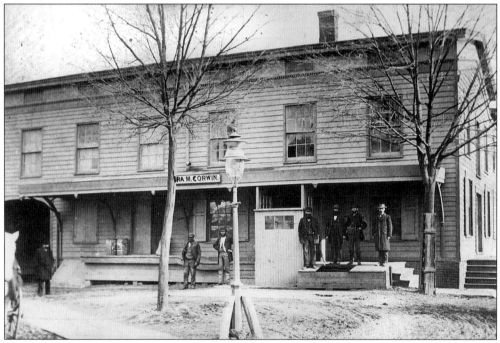

This early photograph shows Ira M. Corwin's establishment, which was on North Street, opposite Sweet's Hotel. The building still stands today. Many people remember Weber's Men's Store, which occupied the site for many years.

The famed North Street building called Gothic Hall was the home of the Middletown Evening Press in this 1870s view. Local feminist Lydia Sayer Hasbrouck was married to the editor of the paper and often wrote for it. Her own newspaper the *Sybil*, which championed women's dress reform, was published here.

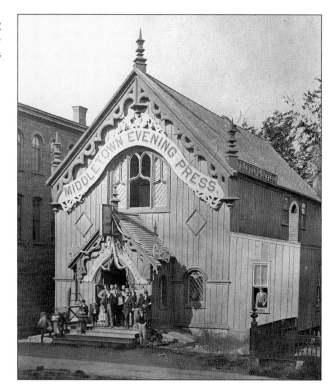

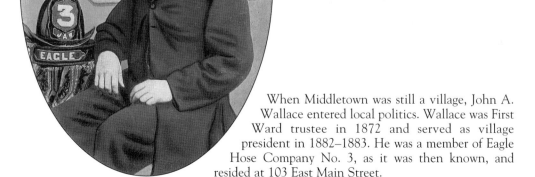

When Middletown was still a village, John A. Wallace entered local politics. Wallace was First Ward trustee in 1872 and served as village president in 1882–1883. He was a member of Eagle Hose Company No. 3, as it was then known, and resided at 103 East Main Street.

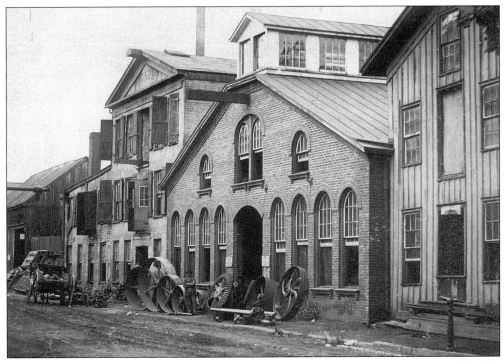

The imposing buildings of the Orange County Foundry are shown in the year 1887. The foundry was an important local industry, and its street was called Foundry Alley, later Foundry Street. The present name of Center Street does not have the same ring to it.

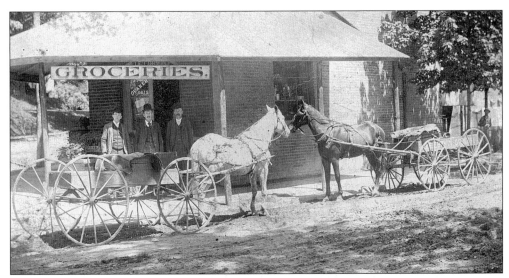

John E. Corwin's grocery was a lively place when this photograph was taken in 1887. It was located at North Street and Wickham Avenue.

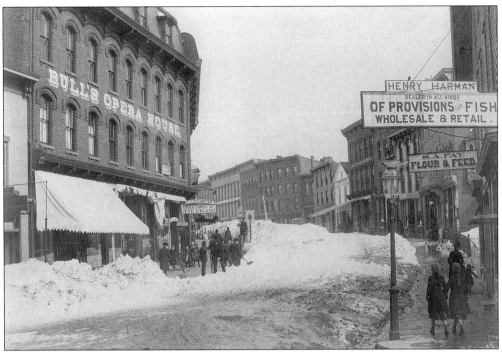

This view of West Main Street at Canal Street was taken looking toward Franklin Square on March 12, 1888, after the famous Blizzard of '88. The sidewalks are getting cleaned, but the streets are still piled high with snow. Many buildings in this photograph still exist, including Bull's Opera House.

Middletown became a city in 1888, and here is the first mayor, John E. Iseman. Iseman and many of his descendants were bakers and had a shop on James Street. The Iseman Building, built in 1887, still stands at this time.

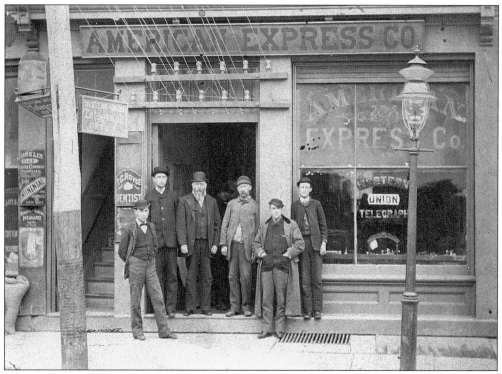

This early photograph shows the American Express Company and Western Union office. The location was East Main Street near Franklin Square. Shown are W.H. Owens, Albert Fahr, Captain Lytte, John Simmons, Thomas Girard, and William Koch.

Middletown's only octagon house stood on Linden Avenue. Feminist Lydia Sayer Hasbrouck and her editor husband, John Hasbrouck, owned the house. Eight-sided homes were a fad in the post–Civil War era. The historic building was razed to make way for Memorial Junior High School.

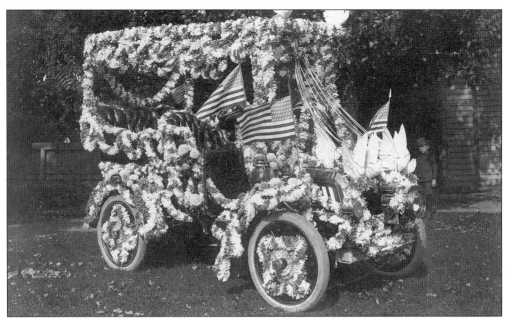

Charles V. Predmore, owner of Middletown's first automobile, displays a 1901 Thomas one-cylinder tonneau. The car is shown in front of 108 Monhagen Avenue, decorated for a parade or exhibition. A famous early make, Thomas cars were manufactured in Buffalo. Predmore's first car was a Locomobile.

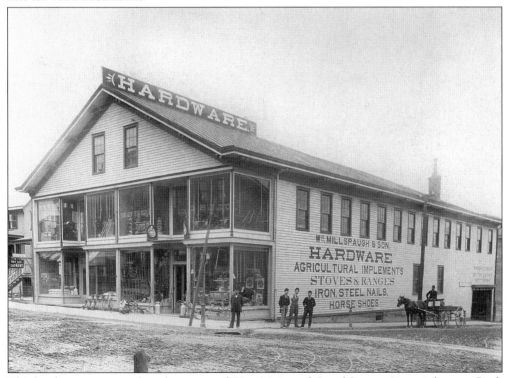

This hardware store stood on the corner of West Main and Canal Streets. Later, it became Buck Brothers Hardware Company. The photograph was taken in the 1890s.

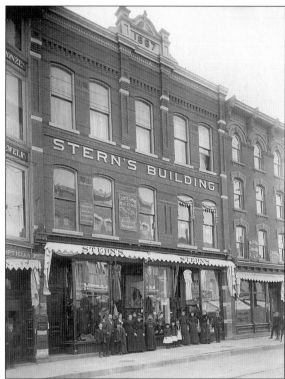

Stern's Department Store was located at 13–15 North Street. The occasion for this 1894 photograph is not known. Stern's was one of Middletown's premier department stores, others being Tompkins, Demerest's, and Carson & Towner's. Proprietor Lehman Stern began his career as a peddler.

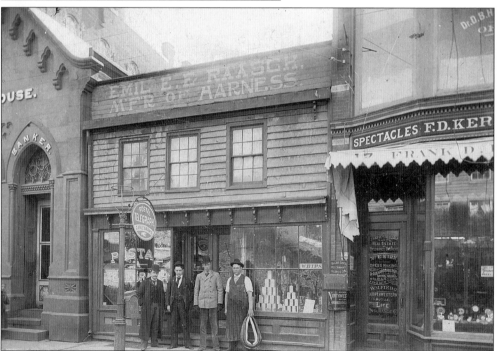

On North Street, next to Kernochan's Jewelry Store, was Emil Raasch's harness shop. The building on the left was Corwin's Private Banking House. In this 1896 photograph, Emil Raasch is on the right.

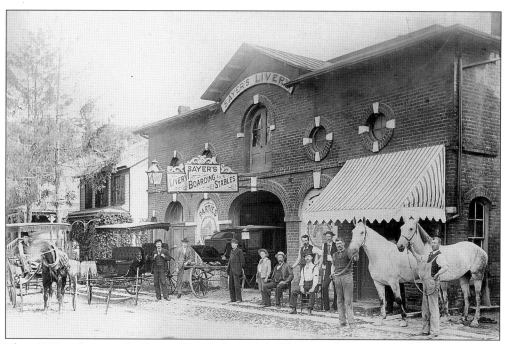

This 1890s photograph shows Sayer's Livery Stable on John Street. The building later progressed from the horse era to a garage for automobiles. Orange County Telephone Company later built its headquarters on the site.

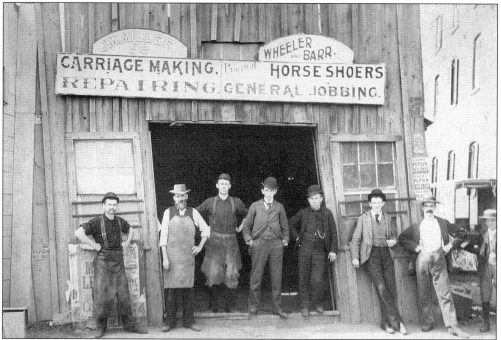

A blacksmith shop was a civic necessity years ago. This was the shop of Wheeler & Barr, a longtime local business, located at 96 North Street. In this 1890 photograph, E.A. Wheeler is on the left.

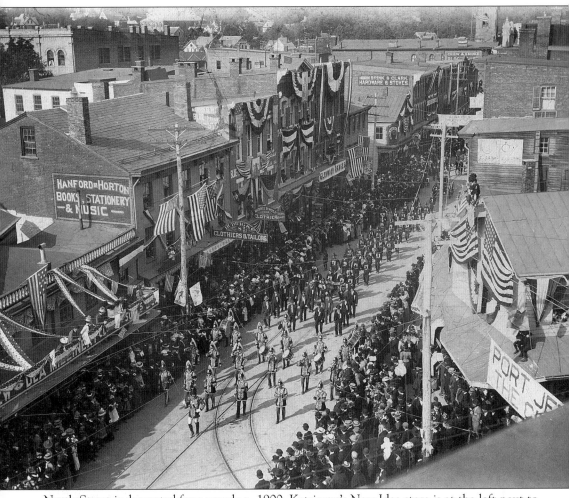

North Street is decorated for a parade *c*. 1900. Katzinger's New Idea store is at the left next to Hanford & Horton's. The drum major approaches Franklin Square.

Two
BUSINESS AND INDUSTRY

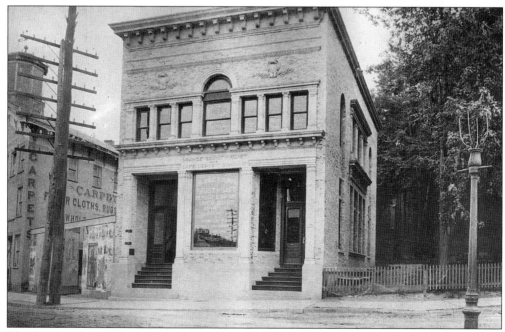

The Orange County Trust Company building, at North and Orchard Streets, looked like this in 1892. The Matthews Brothers Carpet Bag Factory is in the background.

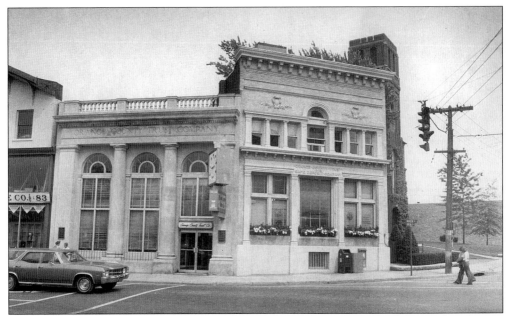

The Orange County Trust Company looks like this today. The building has been considerably enlarged since the days in which the previous photograph was taken.

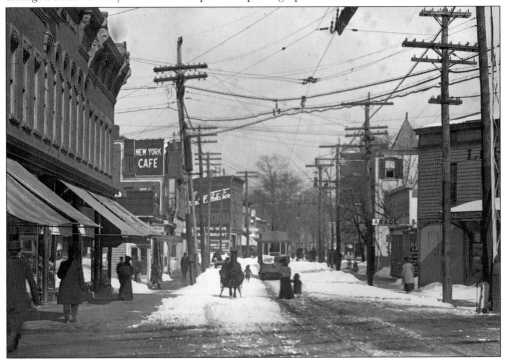

This view shows North Street at the Erie Railroad crossing in the early 1900s. The Corwin Block, later Green's Department Store, is on the left. The trolley may be going toward Wickham Avenue; if not, the woman and child ought to get out of the way. A horse-drawn sleigh is coming toward the crossing. Rutan's Garage is in existence, so a few people in town must have automobiles.

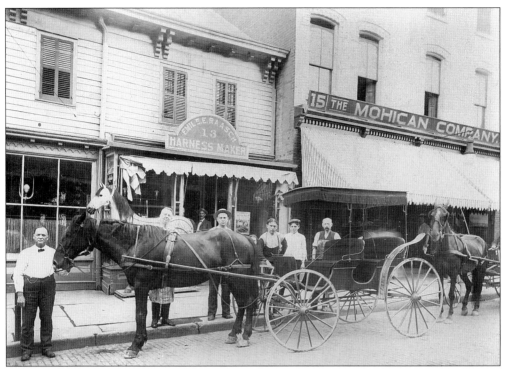

These horse-drawn rigs are on East Main Street. Emil Raasch's Harness Shop is now at No. 13, and the Mohican Company occupies No. 15. The Mohican store stayed in business through 1959. These buildings were torn down shortly thereafter, and site is now a parking lot.

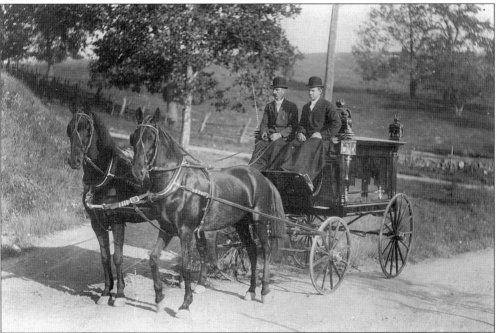

Alexander Merritt holds the reins as he poses in his horse-drawn hearse. The men are wearing derbies and using a lap robe.

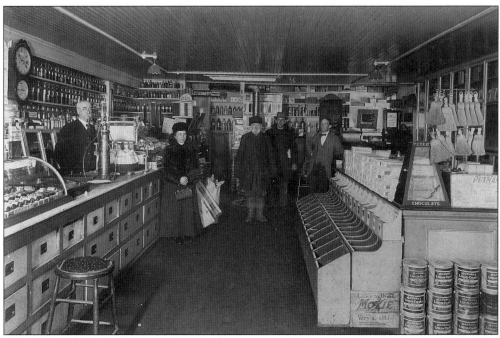

This is the interior of Pronk's Drug Store, at the corner of North and East Main Streets, in 1900. Ferris M. Pronk is behind the counter. George Frint, the druggist, is on the far right.

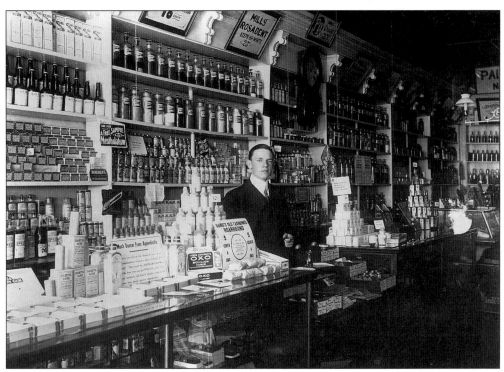

Erskine Mills Drug Store was at 49 North Street. The man behind the counter is most likely the druggist, Erskine Mills.

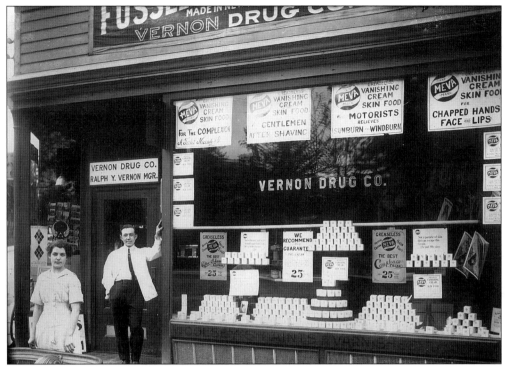

Veteran pharmacist Ralph Y. Vernon opened his first store on Wickham Avenue at the corner of Albert Street. This *c.* 1911 photograph shows Harry and Mabel Knapp. Vernon later relocated to 129 Wickham Avenue, and his store became a neighborhood landmark.

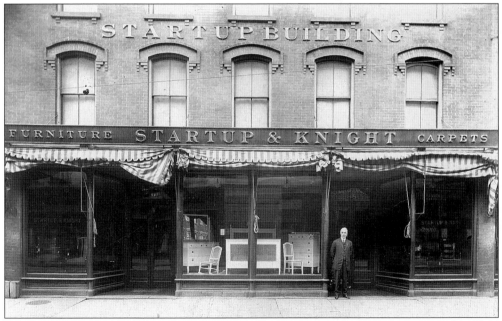

Startup & Knight had a furniture store at 36 North Street. In this photograph, taken *c.* 1907, Walter J. Startup stands in the doorway. The business later became the J.H. Hait Furniture Company.

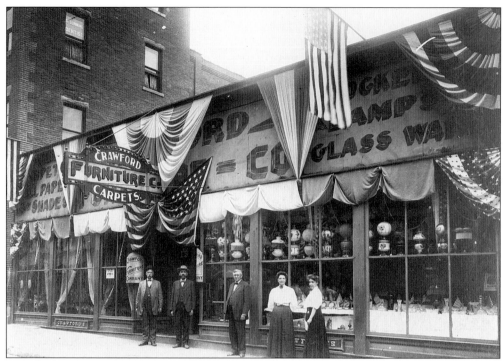

Crawford Furniture Company was a well-known name in Middletown for many years. Shown is the company's old building, at 12 King Street, decorated for Old Home Week in 1908. The three men are George H. Weller, salesman; James Crawford, partner; and C. Emmett Crawford, president.

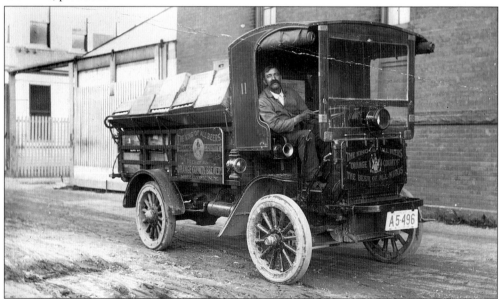

This rare photograph from 1915 shows one of Orange County Brewery's delivery trucks. The truck delivered the "King of All Beers, Beer of All Kings." The photograph was taken in the brewery's yard, on Lake Avenue. The building today has been renovated into the Brewery Apartments.

Most people traveling along Sprague Avenue would never think that Standard Oil Company once had a bulk plant there. This 19th-century photograph shows a portion of the grounds. Socony-Vacuum Oil Company occupied the site until 1943. The property, at the corner of Houston Avenue, later became a part of Polak's Frutal Works.

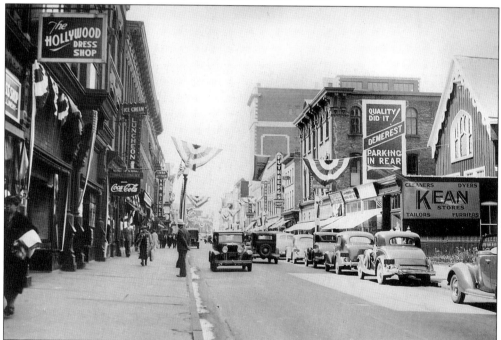

North Street is decorated for Middletown's Golden Jubilee, in 1938. The photograph was taken looking toward Franklin Square. The historical building on the right, partially covered, is Gothic Hall.

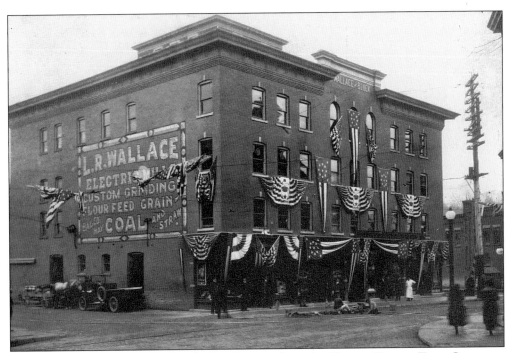

The Wallace Block stood on North Street across from the Orange County Trust Company. This landmark building was torn down in 1959 and replaced with a city park. L.R. Wallace was a dealer in feed, grain, and coal.

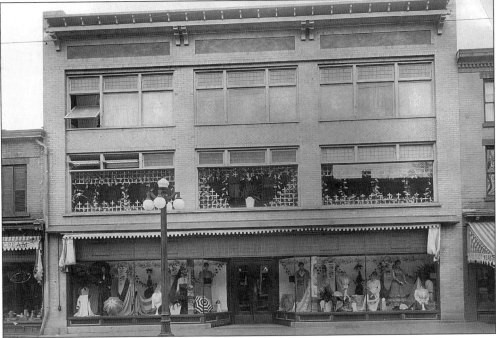

This photograph of Carson & Towner Company's department store and window displays was taken c. 1910. There was no shortage of parking spaces at that time. Carson and Towner's was a local landmark, well remembered by most Middletowners.

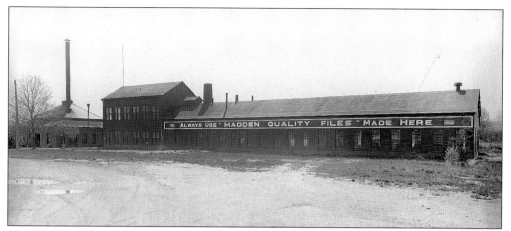

The Madden-Morrison File Company shops were on Dolson Avenue at the Middletown & Unionville Railroad crossing. Portions of this building are still in use.

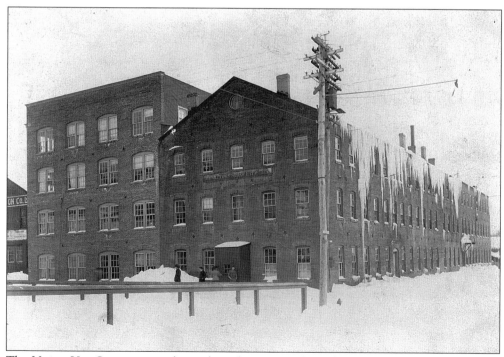

The Union Hat Company was located on the corner of North Street and Low Avenue. The plant later became Hollander Fur Dressers and Dyers and operated for many years.

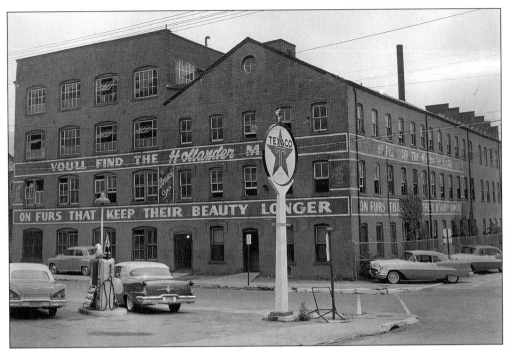

This 1950s photograph shows the same building as in the previous view. The Fur Shop was torn down in 1964 to make room for the expansion of the Rowley Lumber Company's yard.

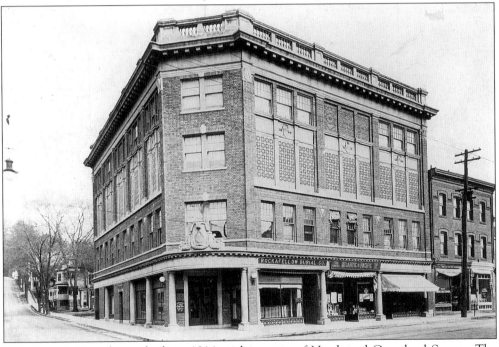

The Masonic Temple was built in 1914 at the corner of North and Courtland Streets. The building is still the home of Hoffman Lodge. Ground-floor stores, however, have changed hands since this photograph was taken. The principal store on the first floor was for many years Weale & Startup's Music Shop. It was followed by the office of the Motor Vehicle Bureau.

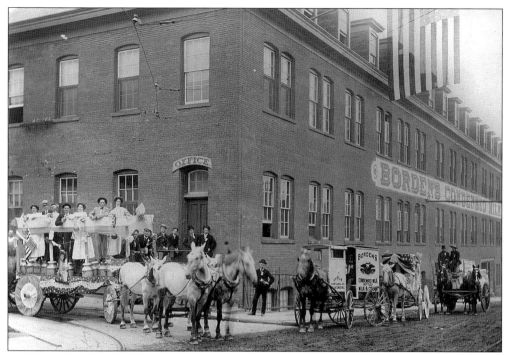

One of the city's largest buildings is the former Borden's Condensery, on Canal Street. This picture shows a float and some decorated milk wagons getting ready for Old Home Week in 1908. Note the trolley tracks and overhead wire that entered the condensery grounds. The building today houses a variety of tenants.

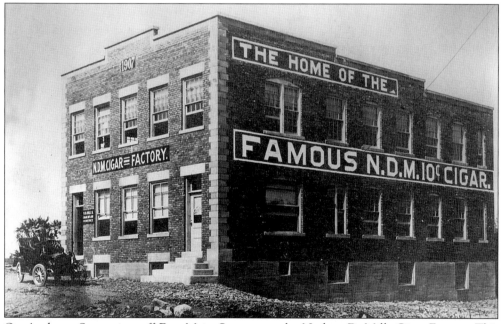

On Anthony Street, just off East Main Street, was the Nathan D. Mills Cigar Factory. This photograph was taken in 1907, the year the building was built. The structure still exists today, although it has been vacant for a long time.

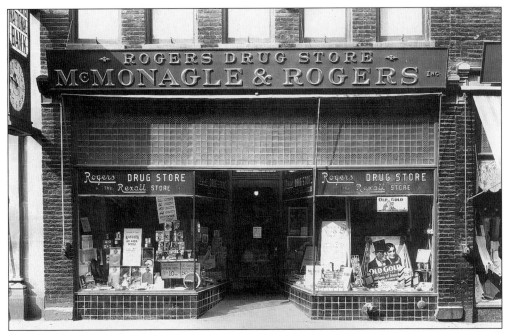

McMonagle & Rogers was a familiar company name in Middletown for many years. The company expanded into the wholesale drug business and erected its main plant on Union Street. Rogers Drug Store was located at 28 North Street, next to the Merchants National Bank building.

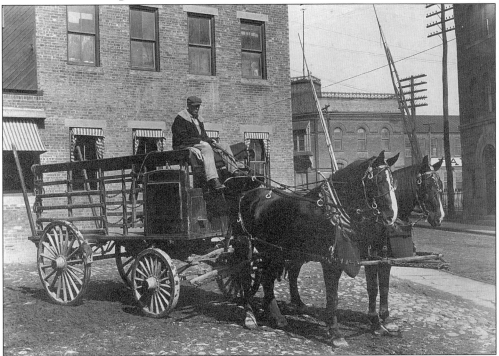

The horse-drawn truck of the Snyder-Fancher wholesale grocery business stands in the company's yard, at 19 Cottage Street, c. 1912. All the buildings visible are still there today.

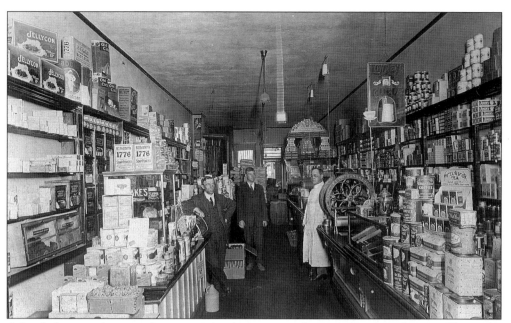

A local photographer must have specialized in interior photographs of retail stores. This is the Hurtin & Dennis Grocery, at 103 North Street. Pictured are Winfield Dennis, George W. Crosby, and Edwin M. Hurtin. Note the cones of white string hanging from the ceiling. Grocers were adept at tying packages.

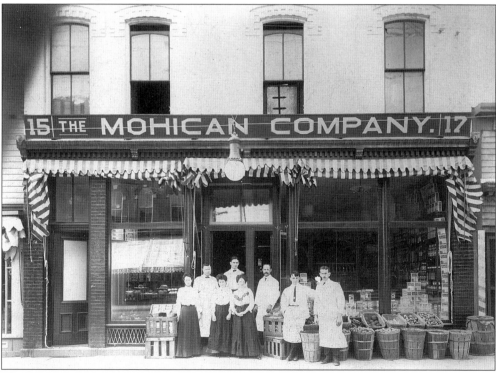

The Mohican Company, an early chain, had a memorable grocery store at 15–17 East Main Street. The employees are pictured in 1902.

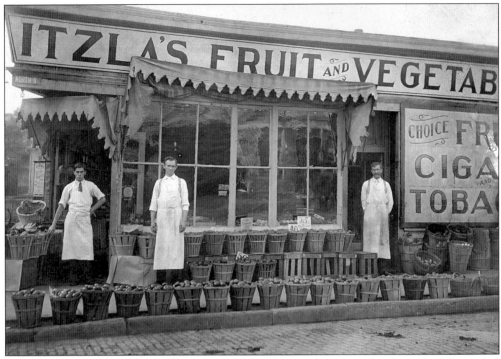

Itzla's Market, at the corner of North and John Streets, has a good selection of fruits and vegetables. Herman Itzla is on the extreme right in this 1910 photograph. The Itzlas were active in Middletown for many years, and some members of the family still reside here.

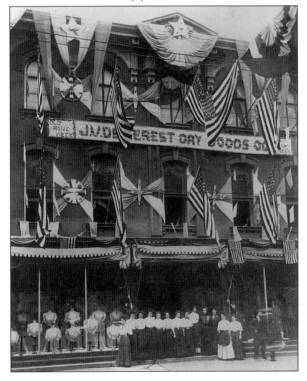

One of Middletown's finest dry goods stores was the J.V. Demerest Company on North Street. The photograph shows the store decorated for Old Home Week in 1908. Flags and decorations were ornate in that era.

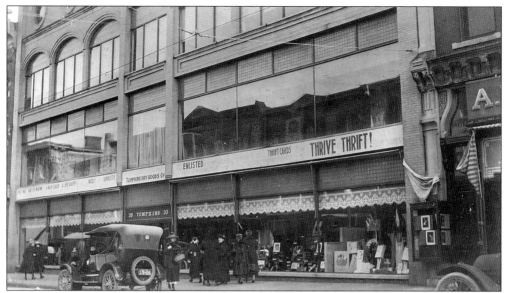

One of Middletown's largest stores, Tompkins Dry Goods Company, at 33–35 North Street, is shown in this view taken prior to December 9, 1918. On that date the building was destroyed in a massive pre-Christmas fire. A new store was built, which still stands on North Street.

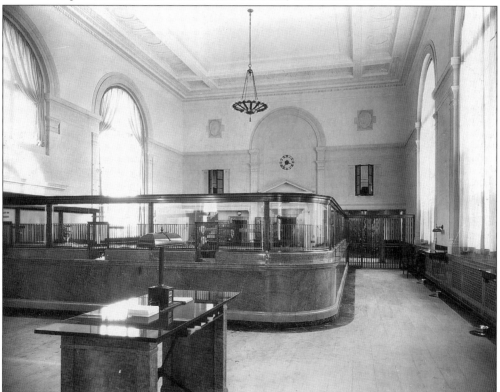

This photograph shows the interior of the new Middletown Savings Bank building in 1924. The view looks in from the South Street entrance. Note the rows of shiny spittoons on the floor. Today, the name on the building is Hudson United Bank.

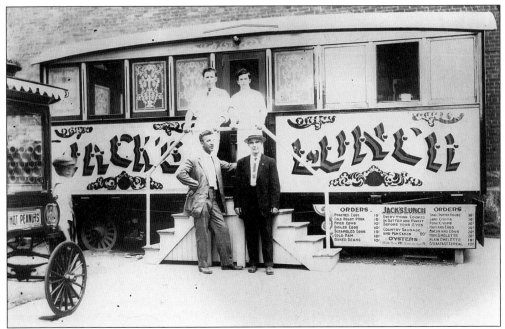

Jack Gaynor (top left) operated a series of local lunch wagons and restaurants over the years. This picture shows Jack's Lunch Wagon on North Street next to Ayres & Galloway Hardware Company in June 1916. Does that read "small porterhouse" for "30¢"? The peanut wagon (left) was owned by George Sulger.

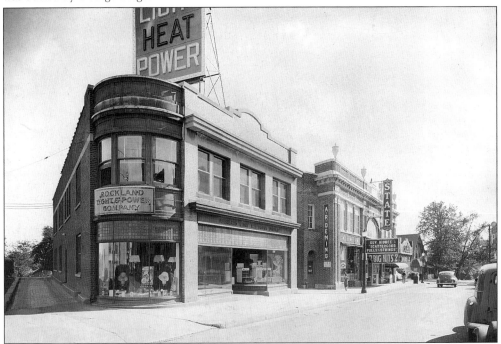

This was the headquarters of the Rockland Light & Power Company on South Street. The sign on roof flashed the words "Light, Heat, Power" alternately. Rockland Light later became Orange & Rockland Utilities. This site is now the Hudson United Bank parking area.

Three

EDUCATION AND HOSPITALS

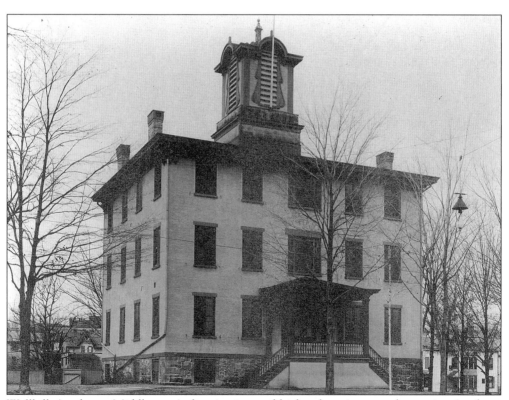

Wallkill Academy, Middletown's first institute of higher learning, stood opposite Academy Avenue Park. The school was torn down in 1896, and the site became the location of Middletown High School. Still later, it became Academy Avenue Elementary School.

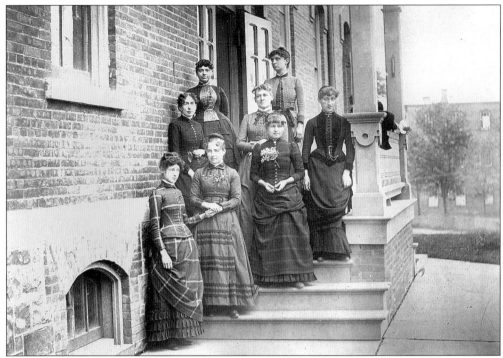

The teachers at Benton Avenue School pose for this picture in 1883. The building in the background is the Manhattan Shirt factory. Ellen Wickham is in the middle, against the wall, and Evelina S. Brett is at the far right.

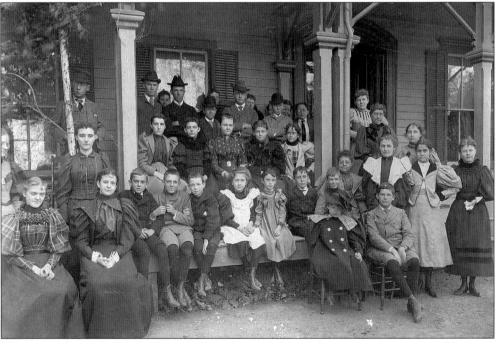

This scene shows the Misses Porter's School, on Highland Avenue at the corner of Prospect Street, c. 1890. Miss E.J. Porter is sitting against the post on the right.

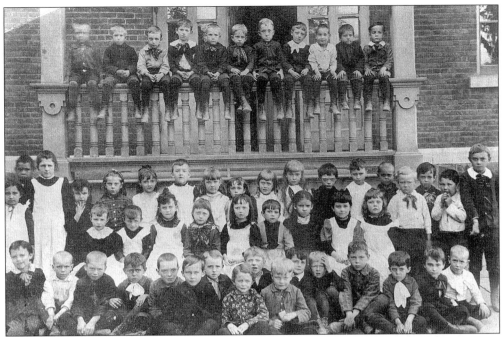

This was a class at Mulberry Street School *c.* 1892. Among the students in this class were Katie Irwin, Cora Jordan, Roy Stern, and Nellie Vail.

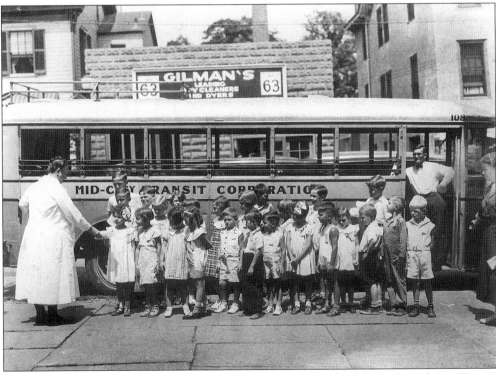

Children from the Middletown Day Nursery line up against the backdrop of a Mid-City Transit bus in this East Main Street photograph from the early 1930s.

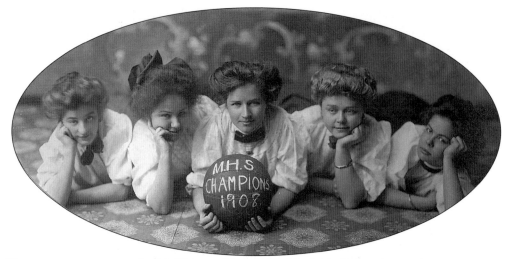

These young women are the Middletown High School basketball champions of 1908.

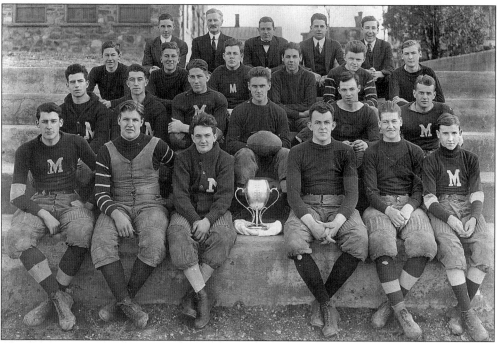

The Middletown High School football team of 1913 won the Orange County High School championship that year. Members are as follows: (first row) T.R. Hart, Charles Sundstrom, Ed Lutes, Gorden Wilson, Bill Marks, and ? Conner; (second row) Bill Southwell, Frank Kramer, Jack Eilenberger, Earl Dickerson (captain), Bill Shoemaker, and Selwyn Gibbs; (third row) Charles Newkirk, Stew Eidel, George Miles, ? Ferguson, Felix Fuess, and Wellington Booth; (fourth row) Ralph Bull (assistant manager), Prof. William Wilson (principal), Prof. Edmund Massey (coach), Stanley Southwell (manager), and Jack Winslow (assistant manager).

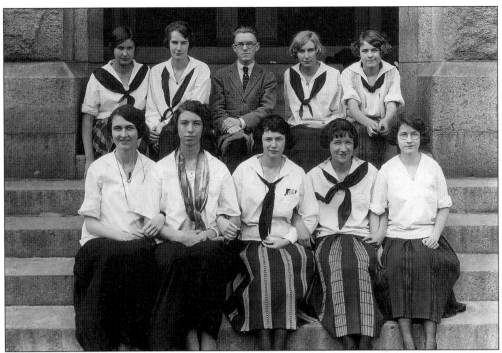

These were Middletown High School's "Best Students" in 1923–1924: Eleanor Hanford, Margaret L. Moon, Ruth Lyman, Marion Simpson, Barbara Kendall, Hazel Bennett, Elizabeth Kirkwood, Cortland Mapes, Helen Lloyd, and Elizabeth Grover. Cortland Mapes, the only boy in the group, became a teacher at Middletown High School. Margaret Moon was the daughter of Truman J. Moon, for whom an elementary school is named.

Once Beattie Hill School, this building on Ridge Street has been converted to apartments.

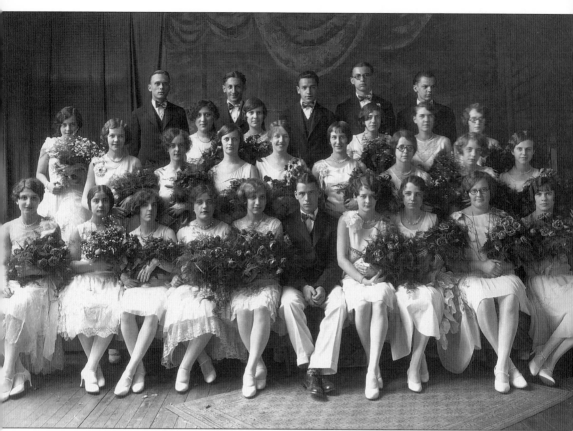

The Middletown High School Class of 1928 poses for a picture. Members are as follows: (first row) Sylvia Schweiger, Angelina Colello (Fusco), Edith Dalley (Doolittle), Lillyan Cohen, Leah Durland (Corwin), Joseph Freehill, Olive Kain (Dill), Ruth Kirk, Ruth Lynch, and Anna Wallace (Evans); (second row) Frances Gray (Travers), Irene Card, Dorothy Towner, Frances Spitz, Katherine Gilmore (Blanchard), and Edythe Pierce; (third row) Sadie Posnick, unidentified, Pearl Toussaint, Maude Loder, and unidentified; (fourth row) Richard Wood, Harry Travers, John Perrino, Murray Roth, and Herbert Hapke.

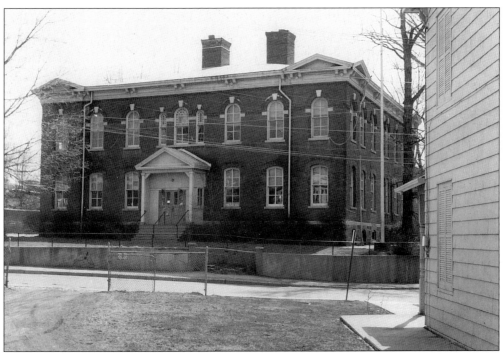

This is how the Benton Avenue School, at the corner of Academy Avenue, looked before it closed. The building was destroyed by fire in 1980, and the site is now a used car lot.

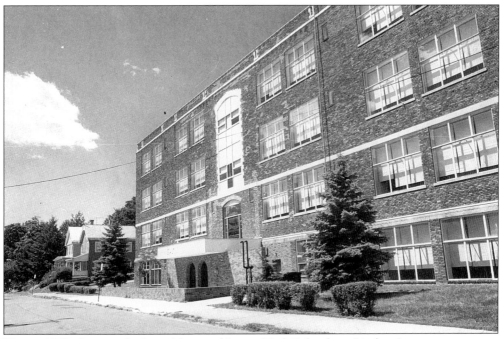

This c. 1960 photograph shows Memorial Junior High School, on Linden Avenue.

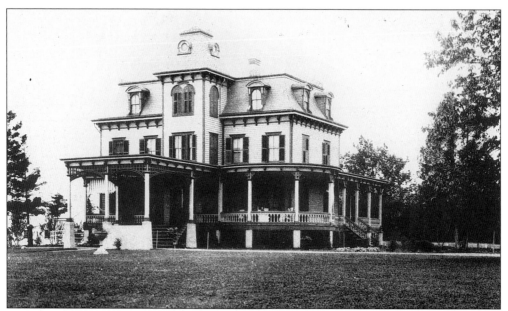

Shown is the Drake home, at the corner of Wisner and Grand Avenues. This is the site of today's Twin Towers Middle School.

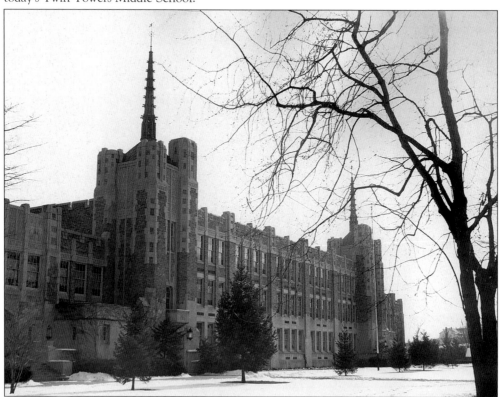

The new Middletown High School, on Grand Avenue, received its first students in September 1940. The building continued as a high school until 1976, when it became Twin Towers Middle School.

In this view the Horton Mansion, on South Street, was under construction. Crewmembers are raising a heavy stone pediment with block and tackle. The bearded owner, Webb Horton, stands at the left. The building later became the Morrison home and, after that, Morrison Hall of Orange County Community College.

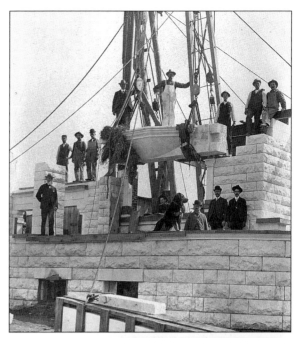

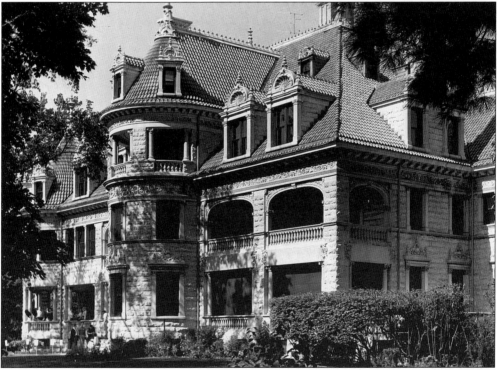

In 1947, with numerous veterans seeking higher education, the Middletown Collegiate Center opened in Middletown High School. From that beginning sprang the germ of Orange County Community College. Christine Morrison's generosity allowed the college to take possession of the beautiful Morrison mansion on South Street. The building is shown on a summer day not long after the college opened in 1950.

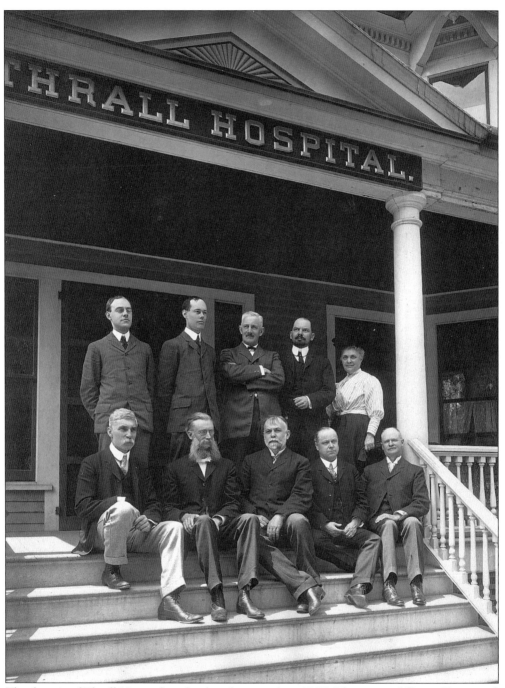

The doctors of Thrall Hospital sat for this photograph in 1907. They are as follows: (front row) Joseph B. Hulett, Joseph L. Hanmer, Edwin Fancher, William E. Douglas, and Theodore D. Mills; (back row) Charles I. Redfield, Moses A. Stivers, Willis I. Purdy, Daniel B. Hardenbergh, and Julia Bradner, one of the founders.

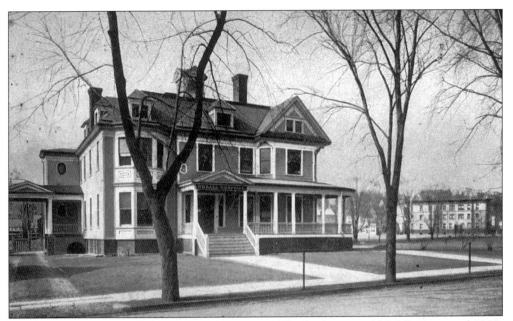

This view shows Thrall Hospital, on Grove Street. The facility served Middletown until 1929, when it was superceded by the new Horton Memorial Hospital.

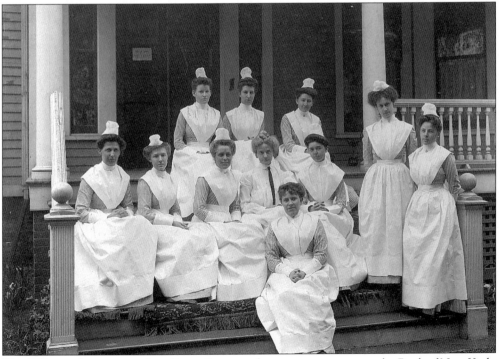

Thrall Hospital was situated on Grove Street at the present entrance to the Bank of New York. This *c.* 1910 photograph shows a group of nurses on the front steps. They are as follows: (top row) Alice Wallace, Laura Mapes, and Cora Peters; (second row) Superintendent Palser, Miss Gregory, Miss Parsons, and Mary Crawford; (at right) Mary Reedy and Blanche Gardner; (in front) Miss Parker.

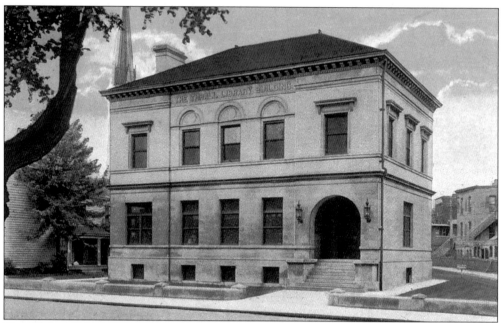

Thrall Library, on Orchard Street, opened in 1901. It served generations of Middletowners. The building was the gift of S. Maretta Thrall. In 1995, the library moved to beautiful new quarters built around the former Erie Railroad station on Depot Street. It is still known as the Middletown Thrall Library.

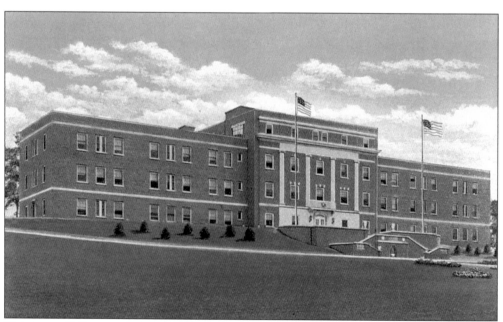

This is a c. 1950 view of Elizabeth A. Horton Memorial Hospital. Located on Prospect Avenue, the hospital has been enlarged several times and is now known as Horton Medical Center.

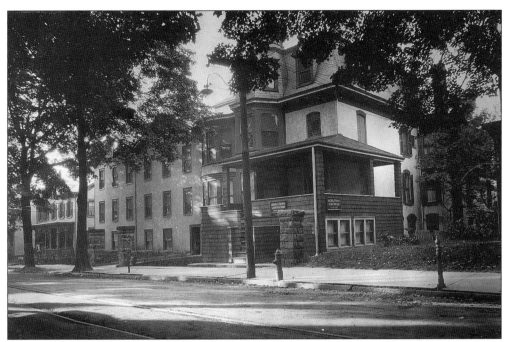

The Middletown Sanitarium was located on Benton Avenue. This excellent photograph shows the facility in the early 1900s. George N. Clemson became interested in the Kellogg Sanitarium in Michigan and was instrumental in establishing such a facility here. Dr. Benjamin B. Kinne is remembered with respect as the head physician.

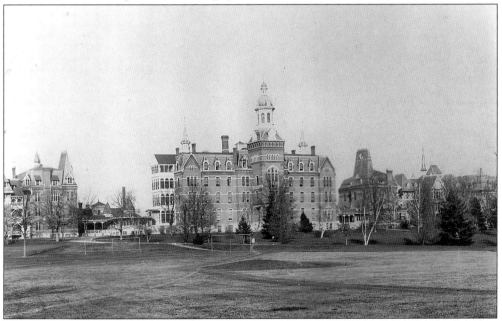

One of the largest facilities in the city was the Middletown State Homeopathic Hospital, located off Monhagen Avenue. This view shows the main building, constructed in 1874. Many other buildings were added to this complex, which for years remained one of Middletown's largest employers.

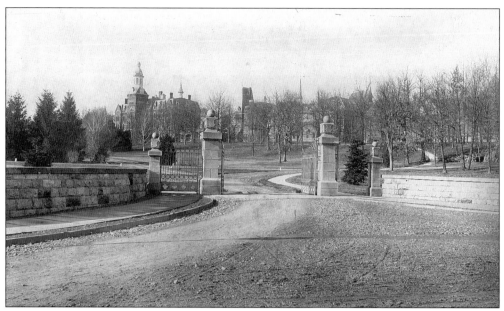

This is the main entrance of the Middletown State Hospital. The main gate on Monhagen Avenue is still there. The street has been paved, of course, and the present-day gate says "Community Campus."

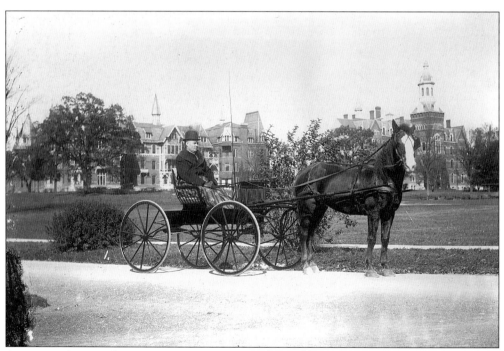

An immaculate one-horse conveyance pauses on the Middletown State Hospital grounds. The driver may be F.W. Meade.

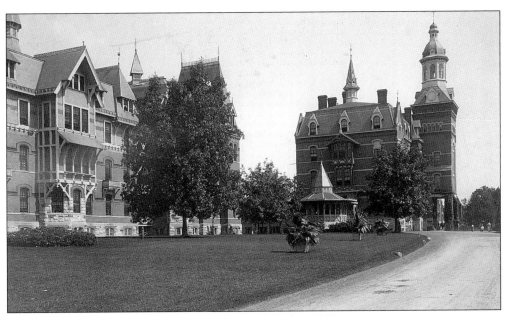

This view shows the asylum buildings and grounds before 1890.

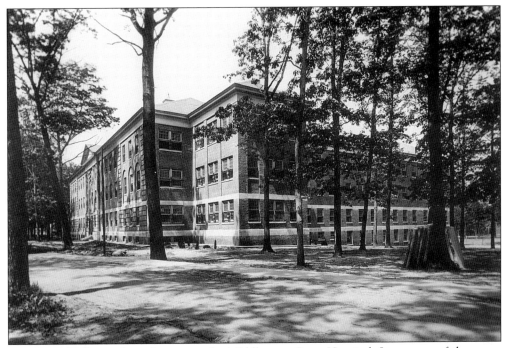

Woodman Hall was the infirmary at the Middletown State Hospital. It was one of the many impressive buildings in the complex.

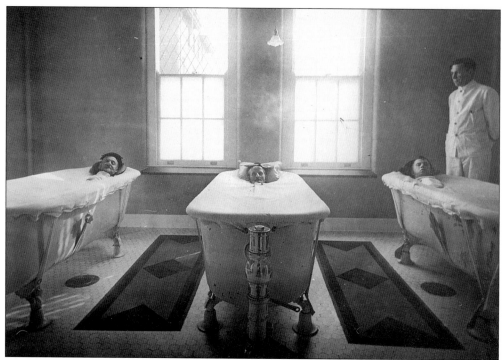

Three patients undergo a form of hydrotherapy at the Middletown State Hospital in this interesting but undated photograph.

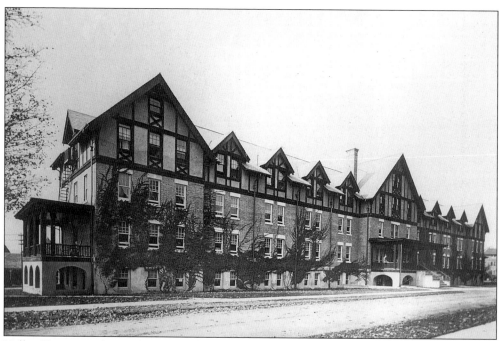

Valley Home was the nurses' residence at the Middletown State Hospital.

Four

HOMES AND
STREET SCENES

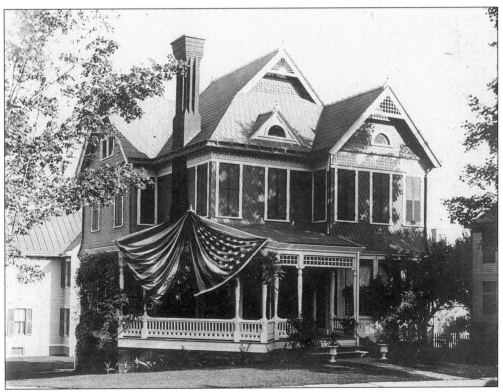

The Edwin Welling Van Duzer home, at 25 East Avenue, is all decorated for Independence Day of 1902. The building is now the home of the Historical Society of Middletown and the Wallkill Precinct. The museum is open to the public on Wednesday afternoons.

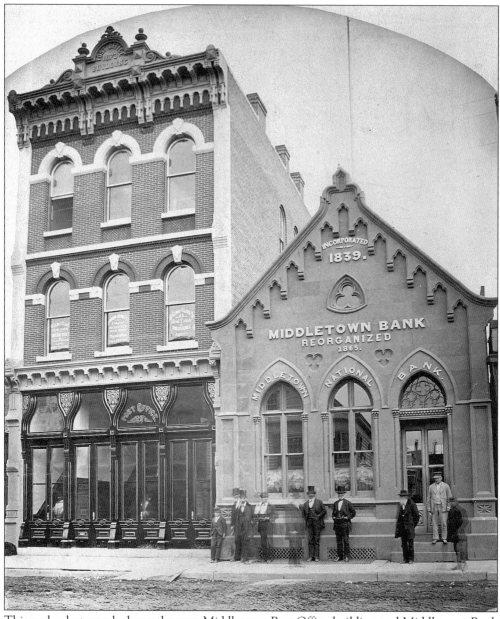

This early photograph shows the new Middletown Post Office building and Middletown Bank on North Street in 1873. King Street is behind the person who took this picture.

This photograph was taken in August 1924. The First National Bank has now been constructed in the North Street section shown in the previous photograph.

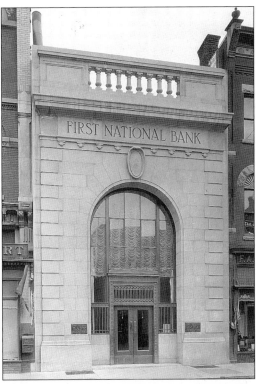

With Gertrude Chambers beside him, Oscar Chambers drives a wagon along Montgomery Street c. 1907. In the bed is James Cutler. The building in the background is the Monhagen-McQuoid firehouse, site of today's Central Fire Station.

This view looking up East Main Street toward Franklin Square was taken from the Monhagen-McQuoid firehouse. Many of the buildings in this 1906 scene are long gone. In the distance on the left is the spire of the Second Presbyterian Church. It is interesting to compare this photograph with the one below.

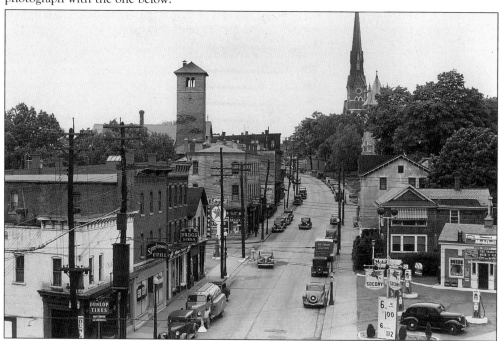

This *c.* 1938 photograph was taken looking up East Main Street from the balcony of Central Fire Station. Webb Horton Church has now been built. The Socony station sells gasoline at six gallons for $1. Socony was an acronym for Standard Oil Company of New York. The Sportsmen's Grill and Morgan's Drug Store were longtime fixtures in this area. The streamlined Texaco tank truck looks far more modern than the automobiles around it.

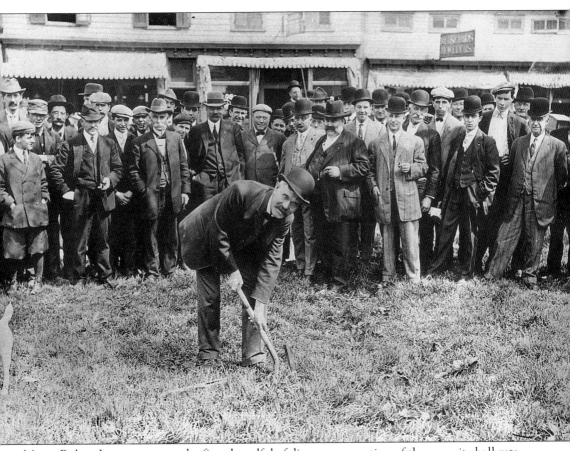

Mayor Robert Lawrence turns the first shovelful of dirt as construction of the new city hall gets under way. The building, on James Street, was opened in 1912. Immediately behind the mayor, in a bow tie, is Charles Higham, Middletown's fire chief.

This view shows West Main Street at the corner of James Street. The property on the right behind trees is now police headquarters. The building on the extreme right has a sign for "Knapp and Merritt, Undertakers." Little in this scene still exists today.

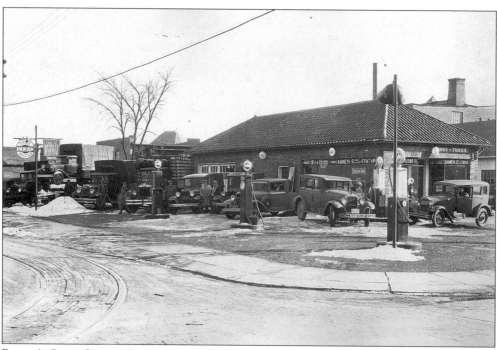

Barney's Super Service Station, at the corner of North Street and Low Avenue, is shown in 1929. Pan-Am gasoline was replaced by Esso in 1934. Today, the building is owned by Agway Petroleum Corporation.

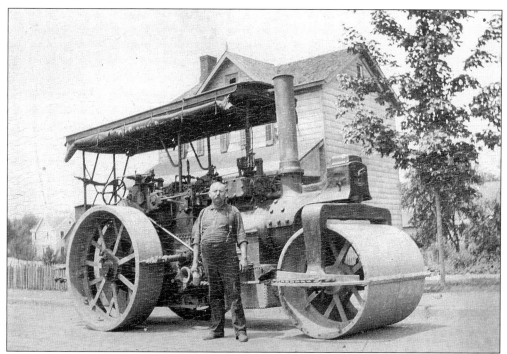

Fortunately, someone had the foresight to photograph Middletown's steamroller and its operator John Horton. When a new Buffalo-Springfield motor roller was purchased in the 1940s, the three large wheels from the steamroller were installed on the new machine.

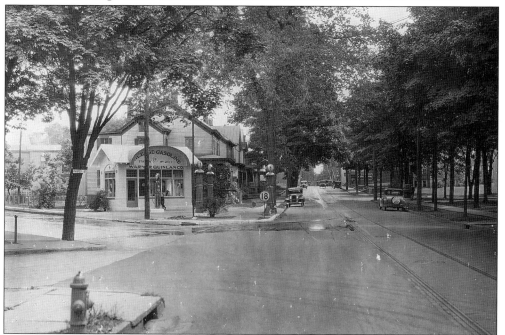

This view shows Wickham Avenue at Smith and Prospect Streets in 1928. Thrall Park is on the right. The scene does not look much different today, except that the price of gasoline is no longer 18¢ a gallon.

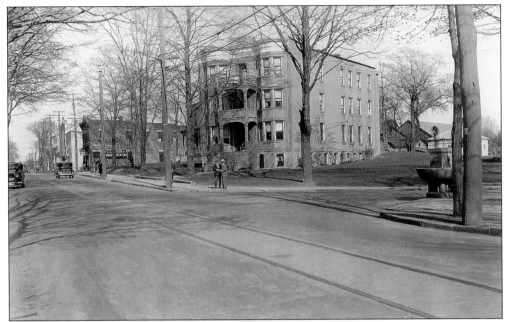

The Franklin Building, at the corner of Wickham Avenue and Grove Street, is pictured in 1928. The watering trough for horses and dogs is seen on the right. Only two automobiles are visible—a far cry from the present time.

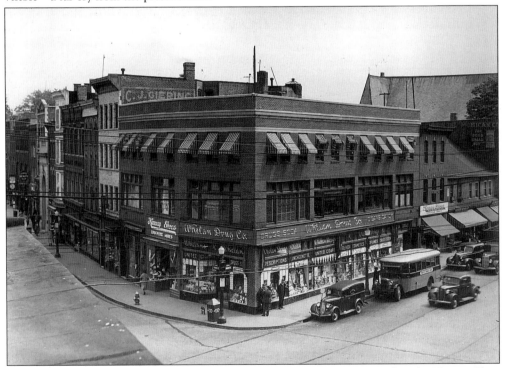

Shown is the Whelan Drug Company, on Franklin Square, in 1933. Note that the Kinney Shoe store had an entrance on both North and East Main Streets. For many years Mid-City Bus Company used this bus stop for one of its routes.

Middletown City Hall is pictured all decorated for the Golden Jubilee of 1938.

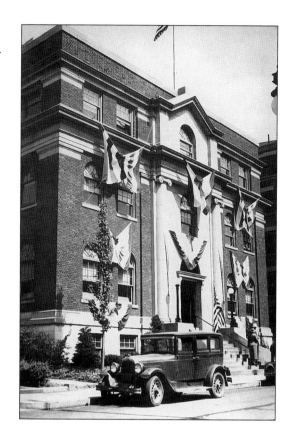

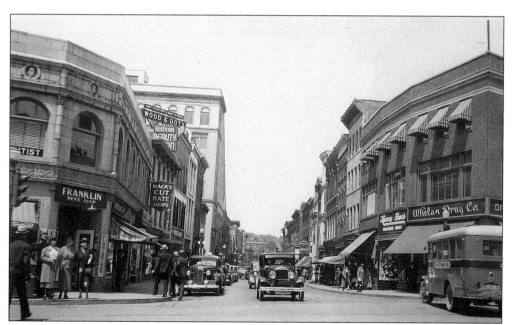

This view, looking down North Street, shows Franklin Square in 1938. The heads of Ben Franklin on the building at the left may have given the square its name.

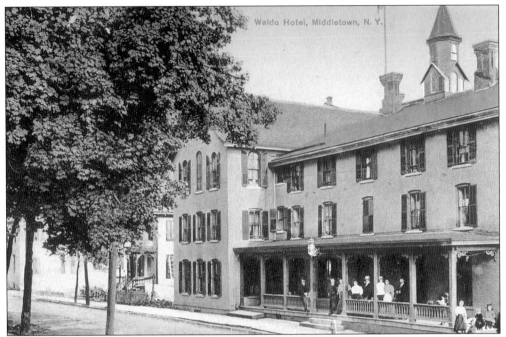

This *c.* 1910 view shows the Hotel Waldo, located on Linden Avenue at the corner of Franklin Street. Popular with traveling salesmen, the hotel stayed in business until the 1950s. Today, the site is a parking lot.

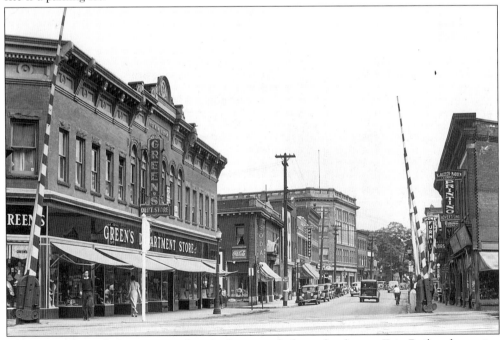

This view of North Street was taken looking north from the former Erie Railroad crossing *c.* 1938. Some once familiar names appear in this photograph. They include Green's Department Store, McCarter's Furniture Company and Home Furniture, and Weber's Men's Store, on the right.

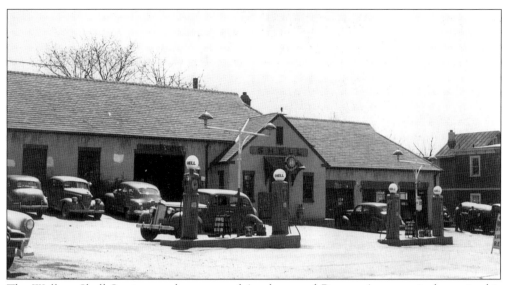

The Wallace Shell Station, at the corner of Academy and Benton Avenues, is shown in this picture from 1951. The gasoline pumps are now gone, but the building has not changed much.

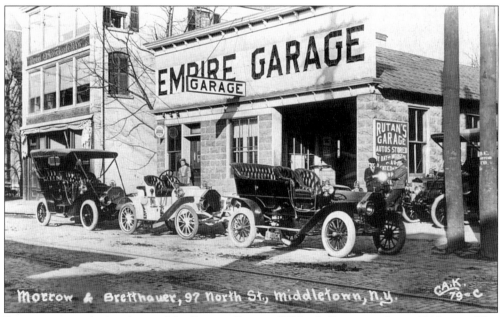

Four cars are parked in front of the Empire Garage, 97 North Street, in this *c.* 1910 view. The car in front has a Buick sign under its running board.

Nothing in this picture is recognizable today. This view of Fulton Street was taken looking toward Monhagen Avenue. The children are standing at the corner of South Street. This whole scene and many more like it were totally changed by urban renewal.

This view shows the same home as in the previous photograph, taken from across Fulton Street. The photograph is not dated but the 1937 Ford car has an "A" gasoline ration sticker on the windshield.

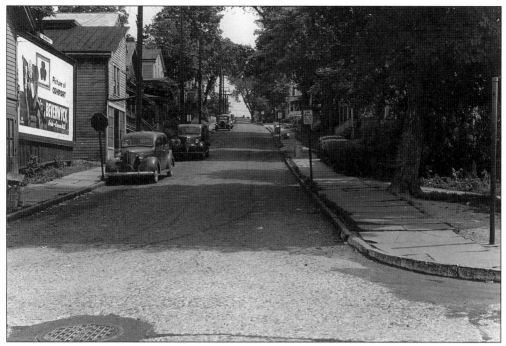

This photograph was taken looking up South Street from Fulton Street. Whelan's Drug Store is barely visible at the top of the hill. Urban renewal was not yet under way.

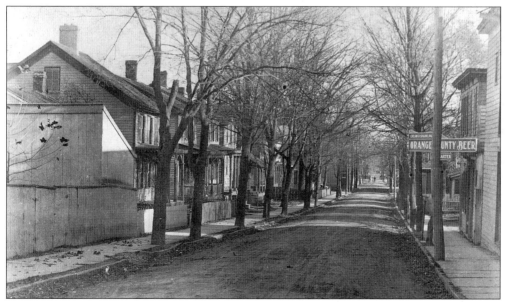

This much earlier view of Fulton Street was taken looking east from Mill Street. Note the unpaved street. The barroom advertises Orange County Beer, made in Middletown.

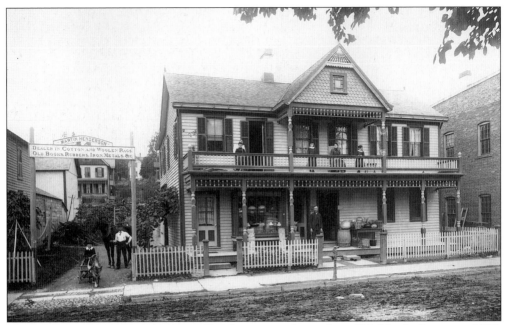

The home and business of Martin Henderson was located at 222 North Street c. 1898. Women and girls on the upstairs porch watch the photographer, as a child on the left enjoys a goat-cart ride.

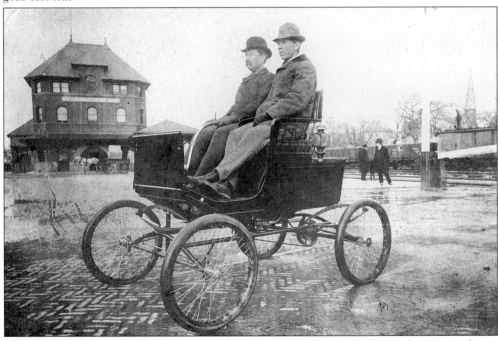

This was the first automobile in Middletown. January 29, 1900—"Charles V. Predmore received his Locomobile Saturday night and Sunday gave the vehicle a thorough trial about town. The Locomobile was placed Saturday night in the Anglo-Swiss carriage house and all day Sunday a crowd of men and boys rubbered at it through the windows." The horseless carriage is shown on Wickham Avenue.

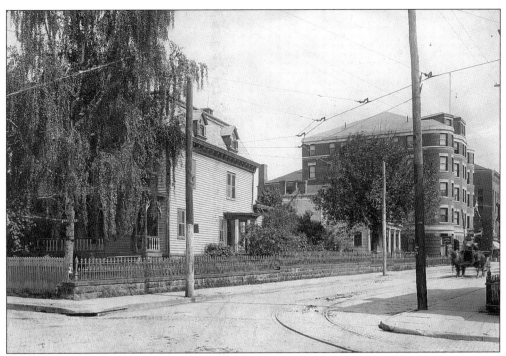

This is how the corner of West Main and James Streets appeared in 1910. The post office and city hall had yet to be built. The Hotel Brown and the Stratton Theater are in the background. Dr. Dorrance's home, on the corner, was demolished to make room for the new federal building.

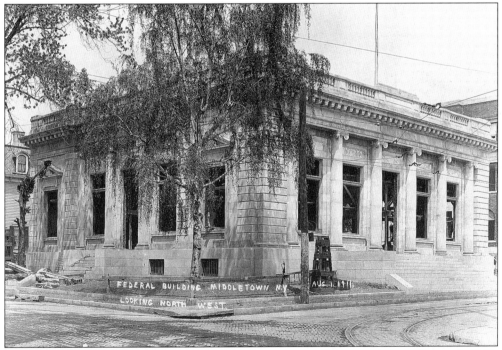

FEDERAL BUILDING MIDDLETOWN N.Y. AUG 1 1911
LOOKING NORTH WEST

This photograph showing the construction of the new post office was taken on August 1, 1911. The trolley tracks curve around onto James Street. Today the building is police headquarters.

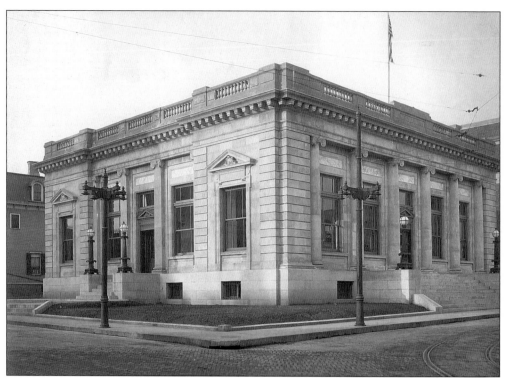

The new post office, or federal building, is shown upon completion in 1911. This building served as the city's post office until 1967. It is now police headquarters. The photograph shows the West Main Street entrance on the left and the James Street entrance on the right.

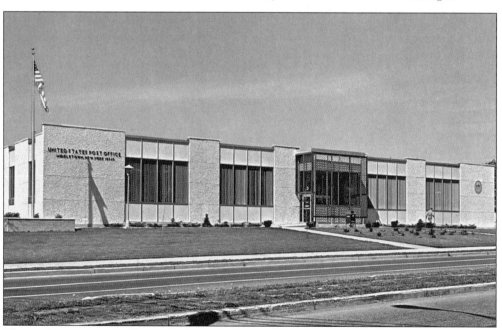

The city's present post office, on Fulton Street, was opened in 1967. It replaced the building on James Street The new post office was erected on land cleared during urban renewal.

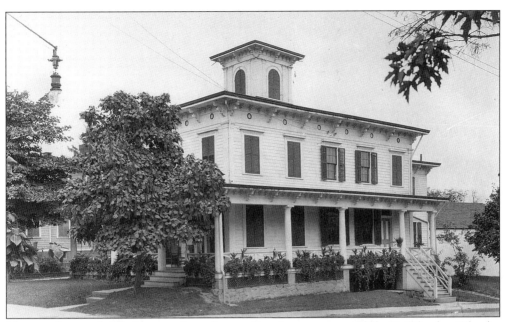

This was the stately Washington Street home of local entrepreneur Elisha P. Wheeler. Wheeler was active in numerous local enterprises, including early railroad ventures. The home later became Elks Lodge No. 1097.

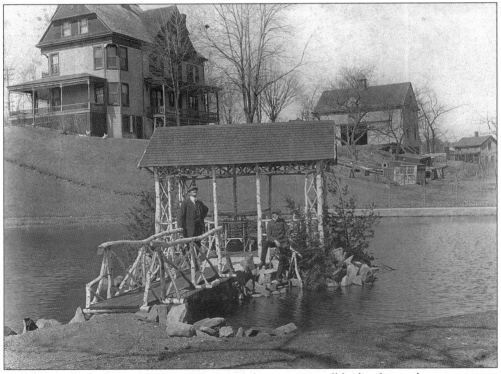

At the Corwin residence, on Wisner Avenue, there was a small body of water known to many Middletowners as the Egg Pond. This c. 1910 photograph shows a bucolic scene. Alas, progress erased this site in favor of a housing development.

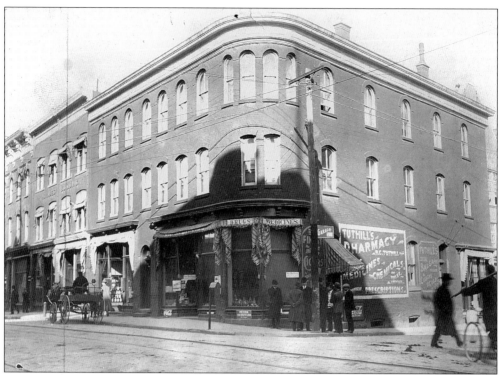

This view shows the corner of King and James Streets in 1911. James Street was a busy thoroughfare in those days. All of the buildings pictured were razed during urban renewal. The entire site is now a municipal parking lot.

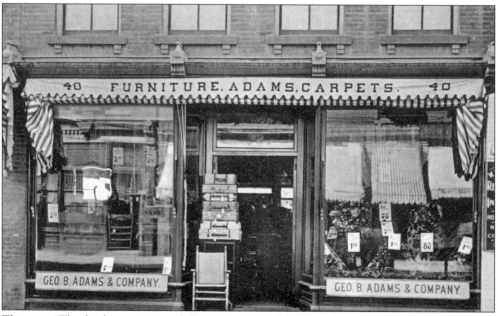

This was "The leading carpet and furniture store of Orange County." So says this postcard depicting the George B. Adams store at 40 North Street.

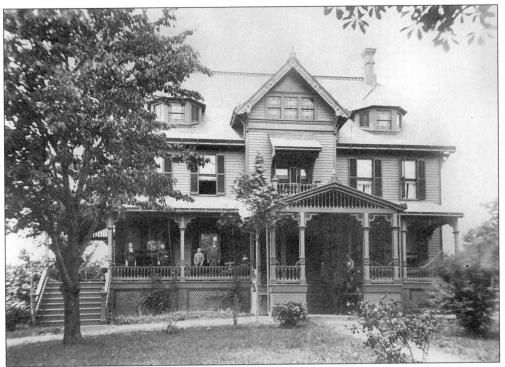

The William Rogers home, at 71 Highland Avenue, was built in 1885. It was torn down in 1968 to make room for the new Temple Sinai.

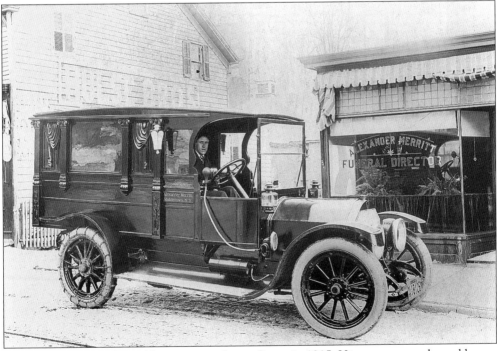

Alexander Merritt's funeral home was on James Street in 1915. His ornate carved wood hearse was equipped with tire chains for snowy or muddy roads.

The home at 12 Washington Street was originally built in 1870 for the superintendent of Borden's Condensery. Today, it is the home of the Junior Order of United American Mechanics, a longtime civic organization.

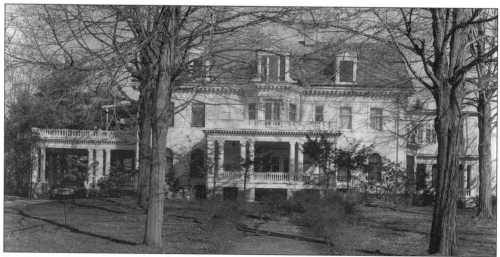

In 1906, Middletown merchant Lehman Stern built this home at 140 Highland Avenue. Shortly before the family moved in, the house was destroyed in a fire. Rebuilt, the Stern family lived there for many years. Later, it became Earle Nursing Home. In 1989, the structure was renovated and, today, it is Highland Manor Condominiums.

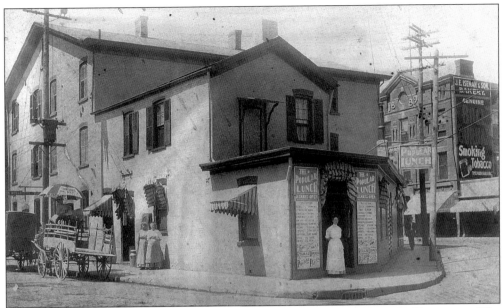

This is the Popular Lunch, a Depot Street eating place located across from the Erie station. The wagons are on Center Street. Bertha Sayer Crawford stands in the doorway in this 1910 photograph. The Iseman building at the rear still stands, everything else was taken away by urban renewal.

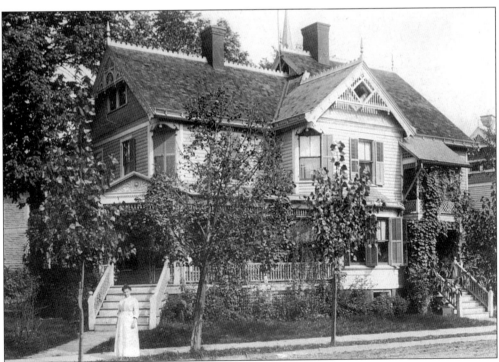

The beautiful period home on Wickham Avenue was the residence of John R. Skelton, whose wife is standing out front. Situated at the corner of Wickham Avenue and Cottage Street, the house was razed c. 1939 to make room for a gasoline station.

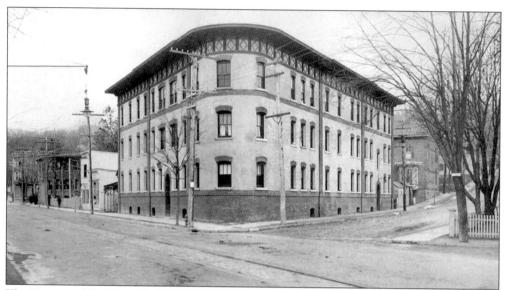

The Townsend Building, at the corner of Wickham Avenue and Prospect Street, was built in 1905 by Garrett T. Townsend. The apartment house looks much the same today as it did then. Thrall Park is on the left.

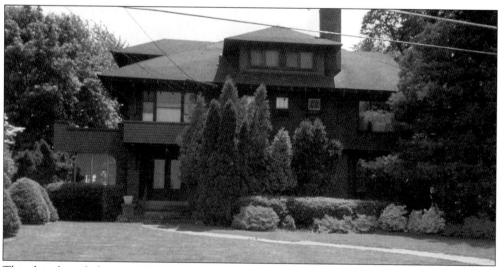

This shingle-style home, at 64 Grand Avenue, was designed by noted architect Frank Lindsey. The former home of John W. Slauson, it was built in 1913.

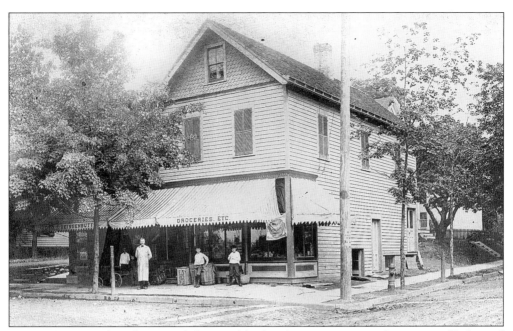

George F. Heissenbuttel operated this neighborhood grocery store at the corner of Lake and Wallkill Avenues. It remained a grocery and deli for many years. Today, it is the home of Super Heros Delicatessen.

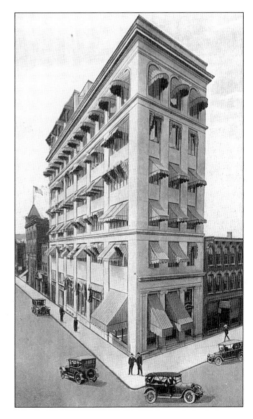

For many years Middletown's tallest building, the Merchants National Bank was one of the city's most prestigious addresses. The building, located on North Street at King Street, remains today, but its cachet is long gone.

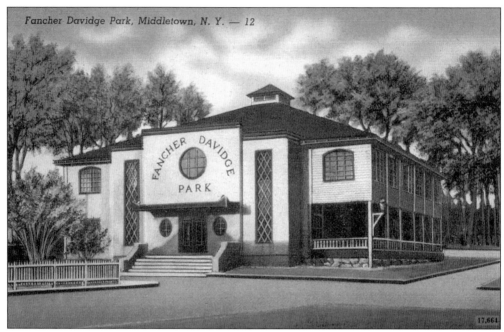

This is the pavilion at Fancher-Davidge Park. The park is still at the end of Lake Avenue, but the building was destroyed by fire in the 1970s.

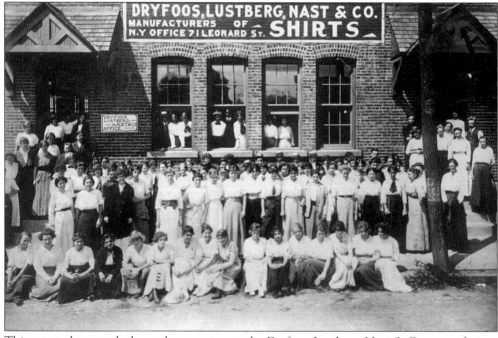

This group photograph shows the operators at the Dryfoos, Lustberg, Nast & Company factory on Academy Avenue. The company also had a plant on Smith Street. The factory shown above became Manhattan Shirt Company. Today, it is Classic Case Company.

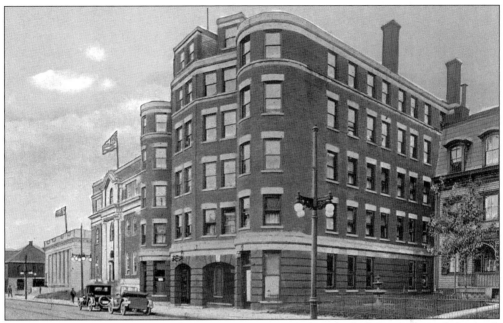

This postcard shows the Mitchell Inn on James Street. The Mitchell Inn remained the city's premier hotel for many years. First Federal Savings and Loan now occupies the site.

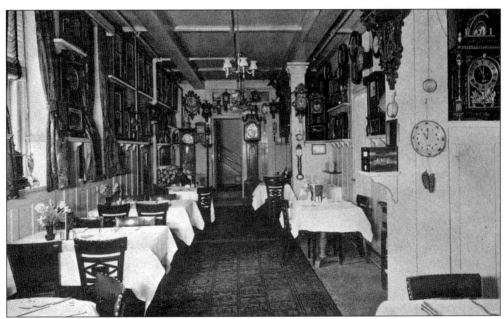

Hotelkeeper Peter Mitchell, a clock fancier, amassed a world-famous collection of timepieces. Many clocks were on display in this well-remembered dining room of the Mitchell Inn, the Clock Room.

This building served as the first home of Hoffman Lodge, Free & Accepted Masons. Located on East Main Street at the corner of Dunning Road, it was built *c.* 1814. Today, the historical structure houses El Bandito, a Mexican restaurant.

Five
PEOPLE

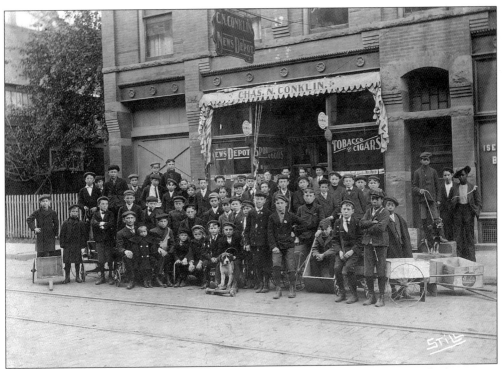

Newsboys wait to collect their papers at C.N. Conklin's News Depot in 1906. The location is the Iseman Building on James Street. Notice the homemade wagons that some of the boys have. C.N. Conklin was succeeded by John Botti.

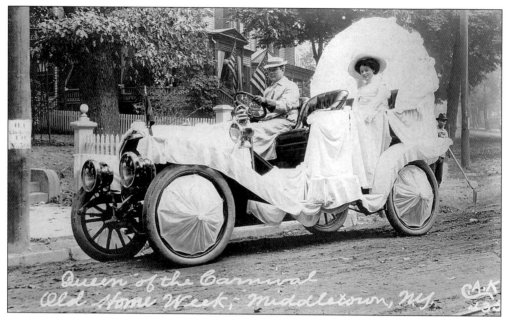

The queen of Old Home Week for 1908 was Isabel Brown, shown in the back seat of this gaily decorated automobile. The expensive car has right-hand drive and leather bucket seats.

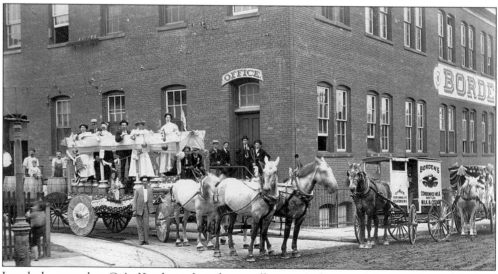

Local photographer C.A. Ketcham shot these milk wagons decorated for Old Home Week of 1908. The scene is Borden's Condensery, on Canal Street. Note the trolley tracks that curved into the complex.

Adele Redhead (Webb) was matron of the Children's Home. The home was located on the site of today's Horton Medical Center.

The Orange County Children's Home, on Prospect Avenue, was in use from 1893 to 1918. The facility cared for homeless children.

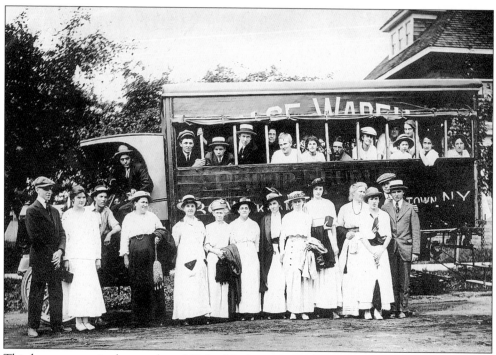

This happy group is about to board Philip Neuberger's autobus. The man in the third window from the front is Frank Jackson, whose relatives preserved this picture.

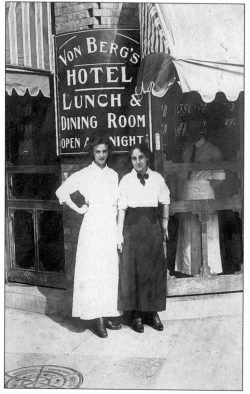

Von Berg's Restaurant, located on Depot Street opposite the Erie station, opened in 1913. The waiter inside watches the photographer. The identity of the women is not known.

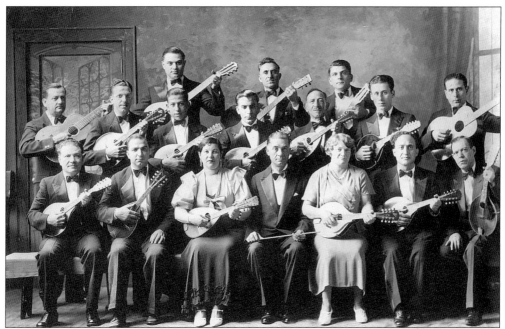

The Middletown Mandolin Club was under the direction of Prof. Salvator Scardigno. Pictured in this July 20, 1934 photograph are the following: (front row) Caesar Fanelli, Dominick D. Russo, unidentified, the director, unidentified, Angelo Ferretti, and Patsy Napolitano; (middle row) Joseph Morreale, James DiRusso, Marianno Raponi, Sam Salvati, Gus Romanelli, Eugene Raponi, and Charles Milan; (back row) Jerry Dragone, Antonio Proia, and Louis Proia.

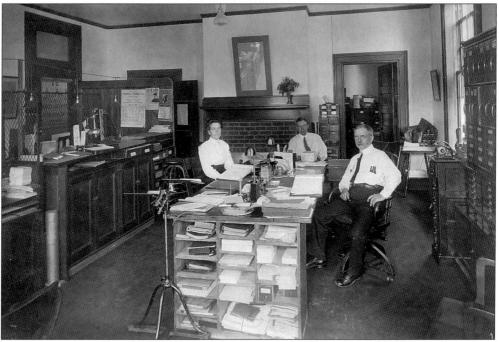

This May 1912 photograph shows the office of the city clerk and treasurer. Pictured are Alice Adams and Allan Rodgers, and, on the right, I.B.A. Taylor, city clerk and treasurer.

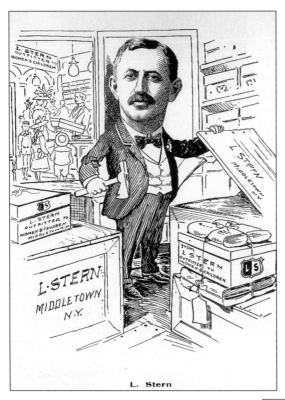

L. Stern

A rare book of 51 pages called *Just In Fun* was published in the early 1900s. It featured caricatures of some of Middletown's most prominent men. Shown are Lehman Stern and Herbert B. Royce. Stern was the proprietor of L. Stern's Department Store. Royce, a longtime local attorney and judge, was a partner in the law firm of Royce, Taylor & Shaw.

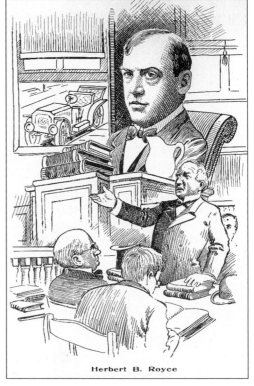

Herbert B. Royce

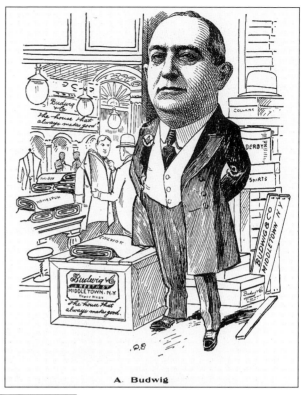

A. Budwig

Two more caricatures show Adolph Budwig, who owned a men's clothing store, and William T. Cornelius, noted funeral director. The complete book may be seen at the Historical Society of Middletown.

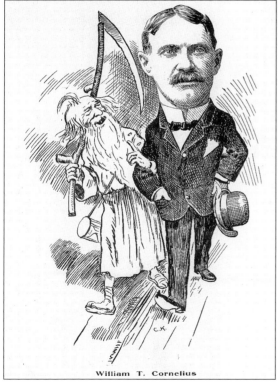

William T. Cornelius

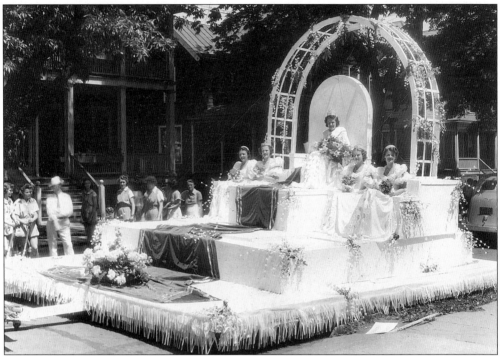

For Middletown's Golden Jubilee in 1938, a gala parade was held with numerous floats. Here is the queen of the Golden Jubilee, Thelma Broadhead, with her attendants, Marion Bennett, Elizabeth Herbert, Anita Chace, and Betty Chace.

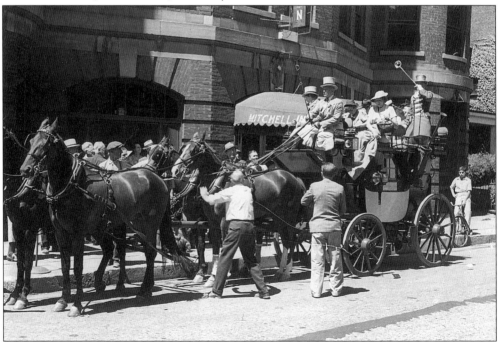

A coach and four prepares to leave the Mitchell Inn, on James Street, in this 1930s photograph. The occasion presumably is a parade, perhaps for the Golden Jubilee.

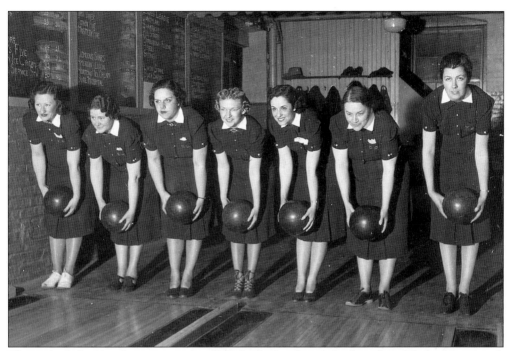

This is the ladies' bowling team in April 1939. The bowler on the far right is Thelma Stanwood, and her team may have been sponsored by Carson & Towner Company, as she worked there for many years. Local team standings are posted on blackboard.

This view shows North Congregational Church and Parsonage, located at 275 and 279 North Street, The front part of the church was erected in 1879, and the parsonage dates to 1898. In 1931, the congregation moved to its new building on Linden Avenue.

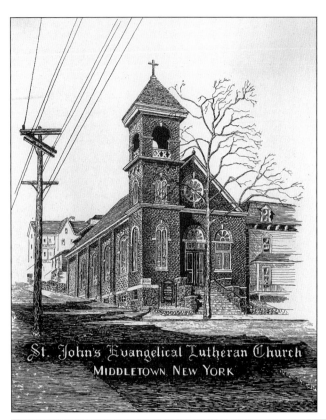

St. John's Evangelical Lutheran Church
MIDDLETOWN, NEW YORK

Two of the unique Christmas cards drawn by Charles L. Radzinsky in the 1960s feature local churches. The artist was a former curator of the Historical Society of Middletown and a former city historian.

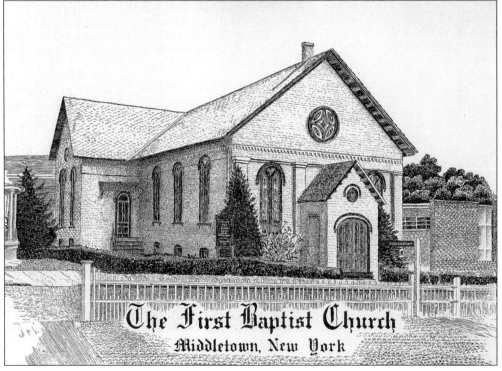

The First Baptist Church
Middletown, New York

The Second Presbyterian Church, on East Main Street, was torn down *c.* 1913 to build the new Webb Horton Memorial Presbyterian Church.

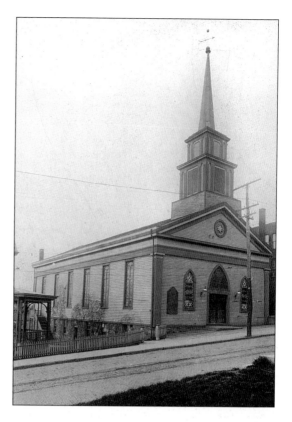

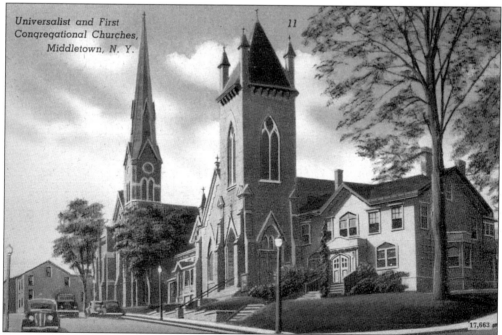

The Universalist church (foreground) and the First Congregational Church are both located on East Main Street. The four turrets on the tower in the foreground have since been removed.

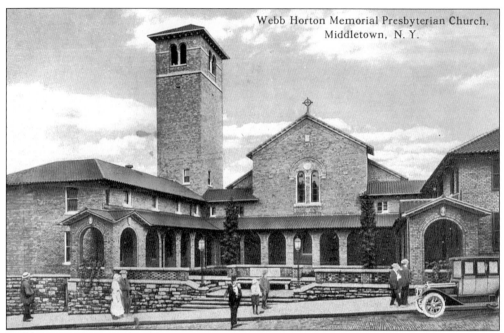

Webb Horton Memorial Presbyterian Church was designed by the renowned architects Carrere and Hastings of New York. This photograph was taken shortly after the building was completed. The structure continues in use today.

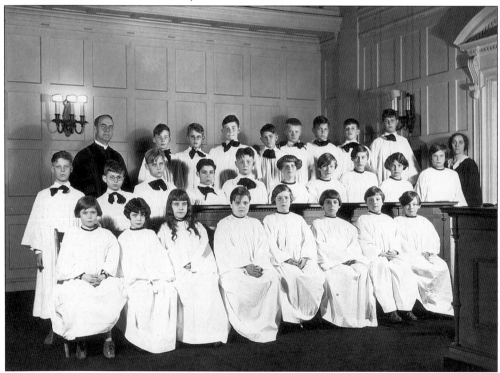

Members of the junior choir of Webb Horton Memorial Presbyterian Church are shown *c.* 1930. Rev. E. Van Dyke Wight and organist Helen Tolles Pelton oversee the group.

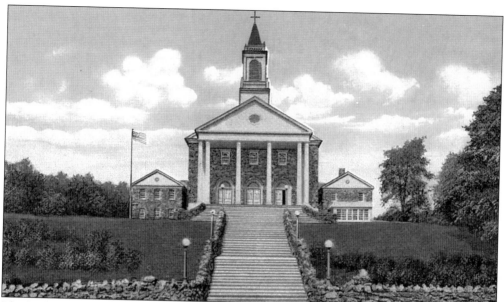

The North Congregational Church, on Linden Avenue, was completed in 1931. The church is built of a rare type of stone said to be found only in Orange County.

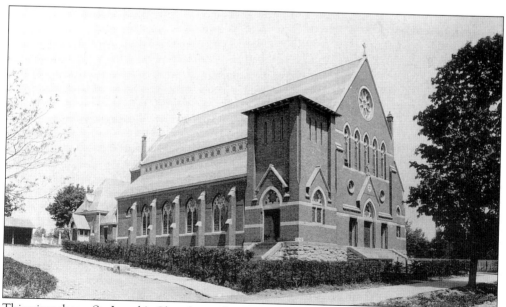

This view shows St. Joseph's Church, on Cottage Street, before the steeple was erected.

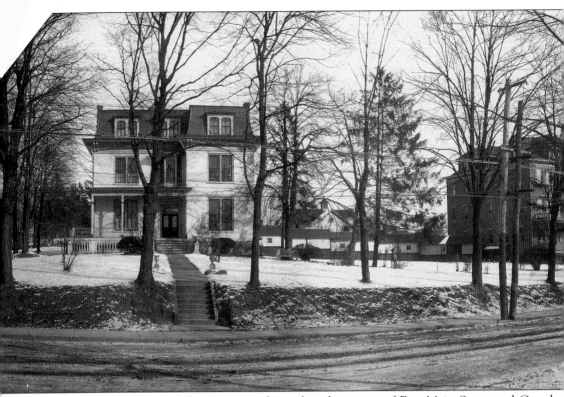

Ursuline Academy and Convent were located at the corner of East Main Street and Grand Avenue. The academy closed in 1951 and was torn down following a serious fire on September 24, 1952. A CVS drugstore now occupies the site.

Six

FIRE AND POLICE

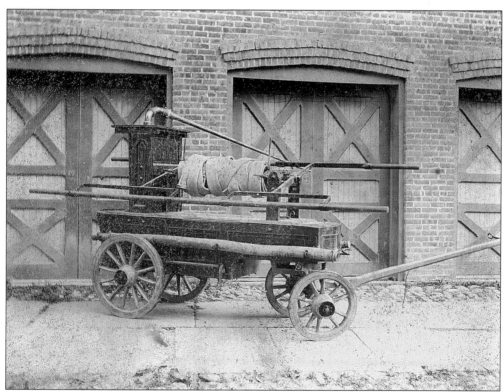

One of Middletown's earliest fire engines was Black Joke, purchased from the New York Fire Department in 1845. (Black Joke was the name of a privateer in the War of 1812.) The historic machine is pictured in front of the Academy Avenue storage garage in 1910. Unfortunately, this pioneer engine was sold for a pittance in 1875, and its wheels were used on a freight wagon.

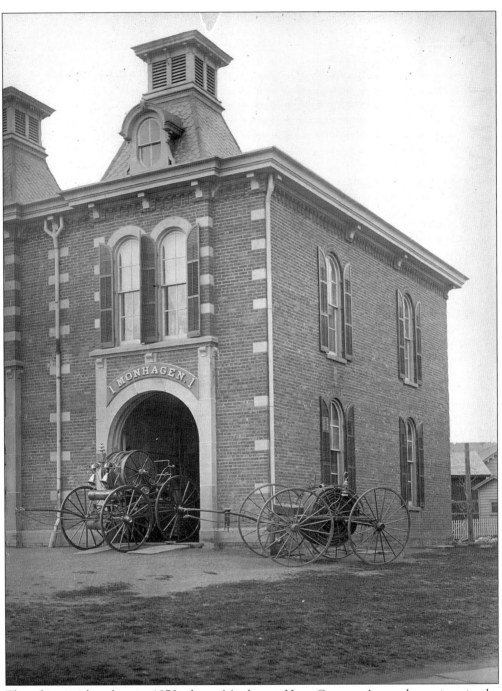

This photograph, taken in 1873, shows Monhagen Hose Company's parade carriage in the doorway while the service hose carriage stands alongside. Two speaking trumpets hang on the tongue. The hose cart's high, narrow wheels allowed firefighters to pull it more easily over rough streets. The site is occupied today by Central Firehouse.

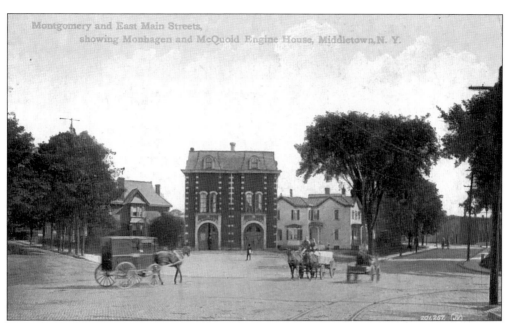

This early view from the 1880s shows the two-bay firehouse that was the home of the Monhagens and the McQuoids. The building was razed to build Central Fire Station in 1928.

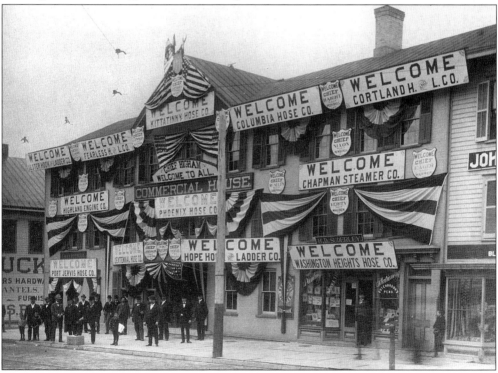

Middletown Fire Chief Charles Higham was proprietor of the Commercial House hotel, on West Main Street at the corner of Canal Street. Higham was fire chief for 25 years and was very well known in state fire circles. His name is pronounced "High-'m." This photograph shows his hotel elaborately decorated for the fire parade of 1899.

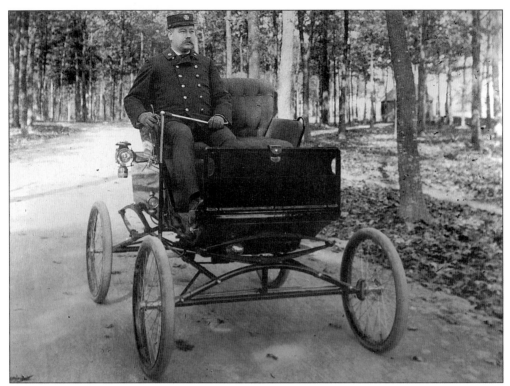

Fire Chief Charles Higham was an avid early automobilist in Middletown. He is shown in his new automobile in May 1901.

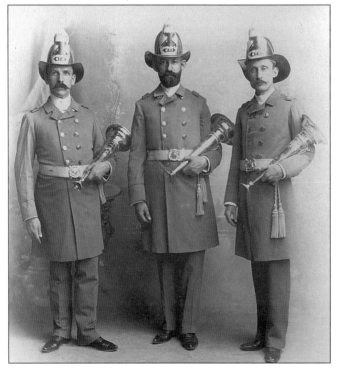

Officers of Excelsior Hook & Ladder Company pose for a portrait in 1893. They are Dewitt D.W. Schoonmaker, foreman; Fred C. Royce, first assistant foreman; and Melvin J. Edwards, second assistant foreman. The men hold their speaking trumpets, which were not only badges of office but also very useful at the fire scene.

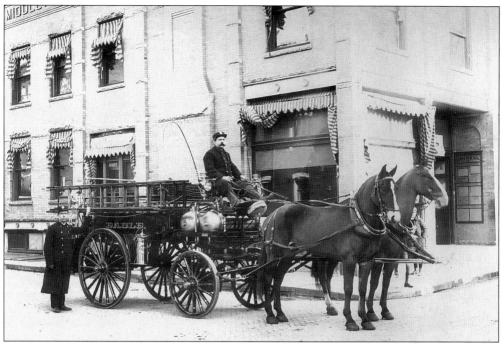

The apparatus of Eagle Chemical & Hose Company No. 2 is shown on Center Street at the corner of King Street. It is a 1900 Holloway chemical and hose wagon drawn by two horses, possibly the bays Prince and Major.

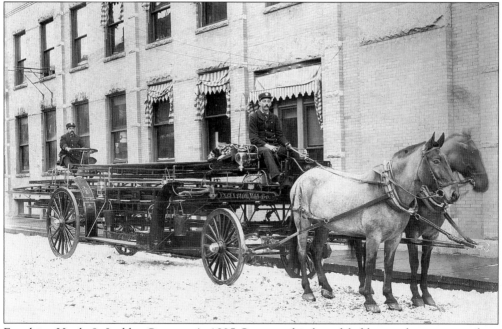

Excelsior Hook & Ladder Company's 1895 Seagrave hook and ladder truck are pictured on Center Street next to the Times Press building. The Eagles and Excelsiors firehouse was adjacent. The horses are probably Frank and Charlie. This truck, as well as all subsequent Excelsior hook and ladder trucks, required two drivers.

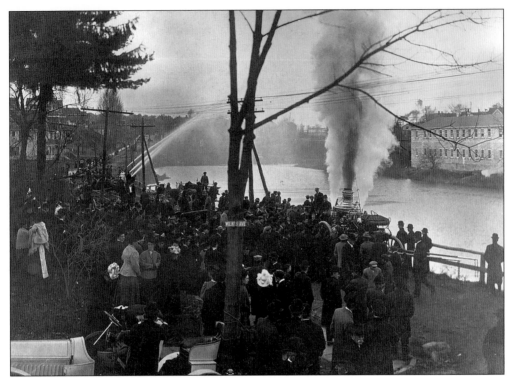

This historical photograph depicts the acceptance tests of Middletown's new steam fire engine. On November 13, 1907, the machine was first steamed at the Mill Pond on Monhagen Avenue. The scene is much changed today, being the site of the city's sand and salt shed. The pond has long since been drained. The American LaFrance steamer is now on display at Museum Village in Monroe.

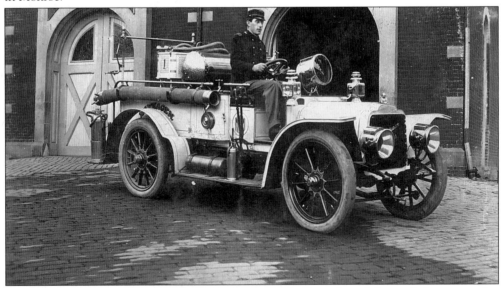

In 1909, the members of Monhagen Hose Company No. 1 purchased the city's first motor fire apparatus. The truck was an American-Mors triple combination pumper, one of the first to go into service anywhere in the country.

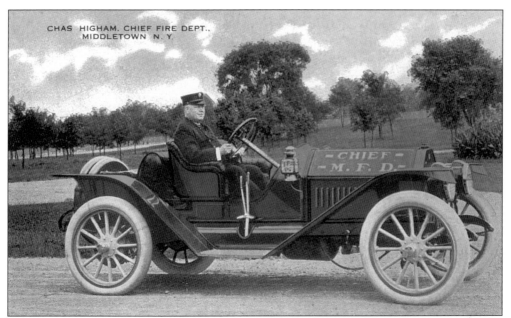

Longtime Fire Chief Chick Higham poses in his new automobile, a 1911 Buick. Higham served as chief for 25 years and relinquished the job only so that others could have a chance to serve.

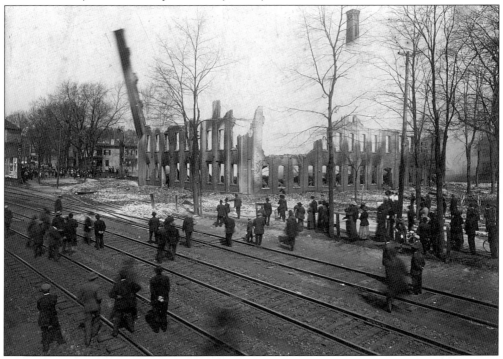

One of Middletown's most spectacular fires occurred on April 26, 1911. The New York Piano Key factory caught fire and burned all night. This photograph, taken the following morning, shows a falling wall. The building was not replaced and the site, at the corner of Railroad Avenue and Grove Street, later housed the S.E. LeRoy Coal Company. At the present time, the site serves as a parking lot.

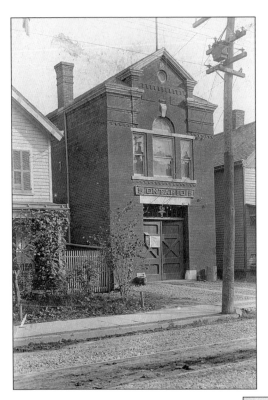

The north end of Middletown was protected by Ontario Hose Company No. 5. This *c.* 1900 view shows the Ontario fire station, on North Street near the corner of Wisner Avenue. The present North Street Fire Station, which incorporates the old building, is situated where the home on the left stands.

Another single-bay firehouse is still in use on Wallkill Avenue. Waalkill Engine Company No. 6 still occupies this building, although the bell tower is long gone. Note that the fire company name Waalkill differs from the street name Wallkill.

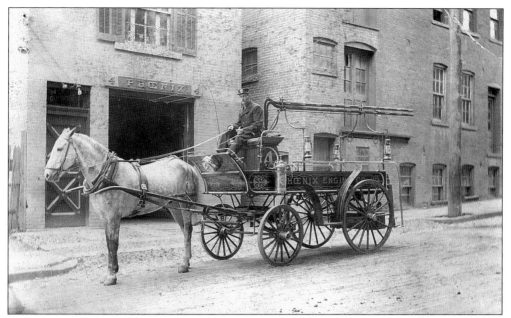

Phoenix Engine Company No. 4 acquired this 1900 hose wagon, shown with driver Harrison Wheeler and horse Old Joe in front of the firehouse on John Street. The old station still stands, much modified, but the large apartment building in the background succumbed to a fire in the 1950s. Visible behind the driver are the two 10-foot scaling, or pompier, ladders that were carried.

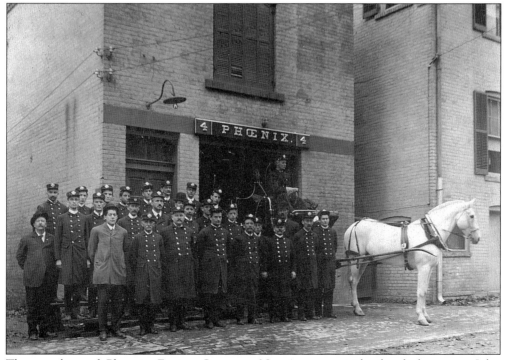

The members of Phoenix Engine Company No. 4 pose outside the firehouse on John Street c. 1900.

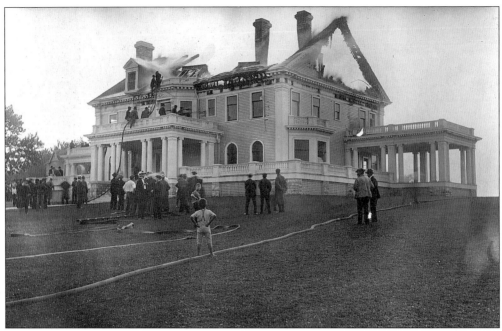

Local architect Frank Lindsey designed this elegant home in the Greek Revival style for downtown merchant Lehman Stern. Located at 140 Highland Avenue, the new home had not yet been occupied when it was heavily damaged by fire on August 5, 1906. The building was rebuilt and, in 1989, it was divided into condominiums.

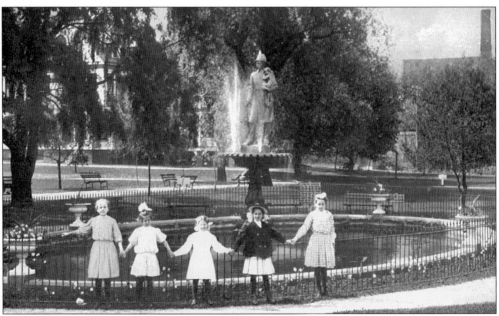

The Firemen's Fountain in Thrall Park was a statue of an old-time volunteer fireman. The fountain stood in the park for many years. In the spring of 2000, it was removed after repeated acts of vandalism. The statue is currently being restored and will be reerected in another location.

Many fire companies maintained a parade carriage as well as a service carriage. Waalkill Engine Company No. 6 received this highly decorated parade carriage from famed builders Gleason and Bailey in 1896.

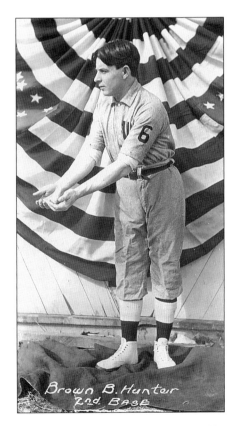

Waalkill Engine Company No. 6 had individual photographs taken of the players on its baseball team *c.* 1900. Brown B. Hunter was second baseman. His uniform looks brand-new.

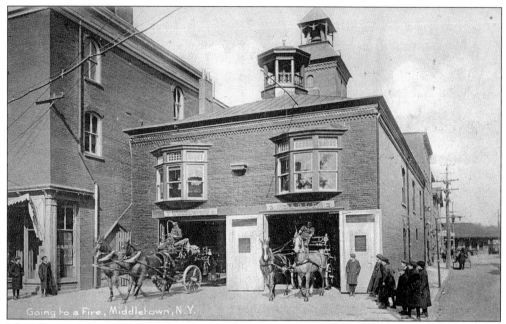

This photograph was taken at the King Street firehouse as the companies respond to an alarm. The firehouse was the home of the Eagles (right) and the Excelsiors. Note the bell tower, visible behind cupola. Used as a fire station until 1928, the old building survived into the late 1950s and was finally torn down as part of urban renewal.

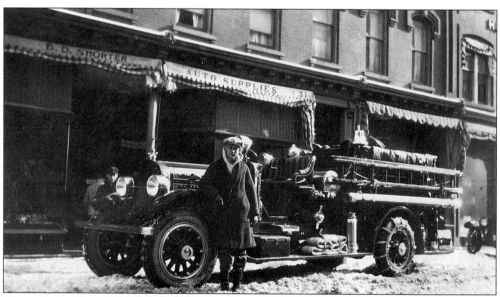

This is Eagle Engine Company's 1922 Stutz pumper on James Street. Open-cab trucks such as this one were cold to drive in the winter.

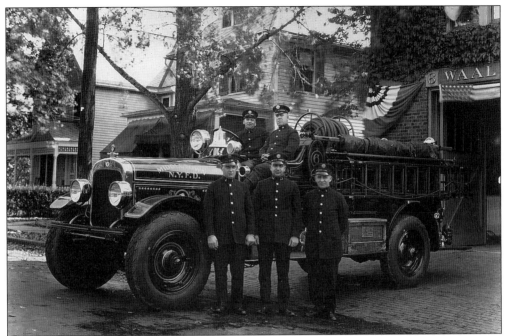

The Waalkills got this beautiful Seagrave 1,000-gallon-per-minute pumper in 1927. The new truck is shown in front of the firehouse. There was an Indian head painted on each side of the hood, in addition to other decoration. The Seagrave Fire Engine Company was noted for its ornate gilt and paint work.

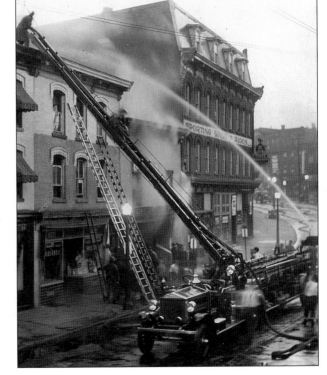

This fire, at 29 West Main Street, occurred on July 31, 1939. Excelsior Hook & Ladder Company's 1927 Ahrens-Fox aerial ladder truck is shown. The building involved was the Eagle Market, next to the former Bull's Opera House. The old opera house was occupied by Roskin Brothers Sporting Goods Company for many years and proudly remains today.

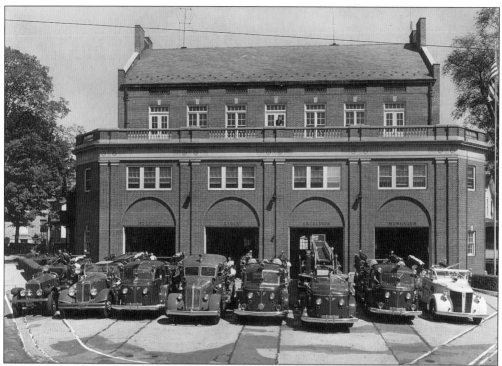

The Middletown Fire Department has turned out its whole fleet for this 1959 portrait. Middletown has seven volunteer fire companies with paid firemen who drive the apparatus.

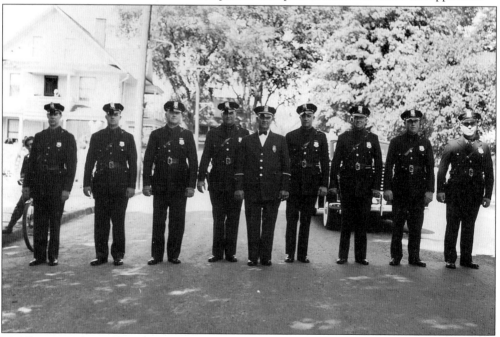

Middletown police officers line up for the Golden Jubilee parade in 1938. Fourth from left is Don L. York, and then Chief Percival Bennett, W. Lowerre, Frank Jackson, an unidentified man, and Fred Walker.

John D. Brinckerhoff was Middletown's police chief from 1902 to 1906.

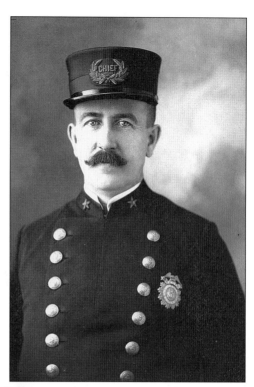

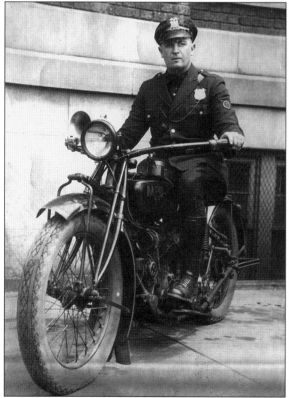

Patrolman George Davis poses on motorcycle No. 1 in the 1930s. The photograph was taken behind Middletown City Hall, where the police station was located at that time.

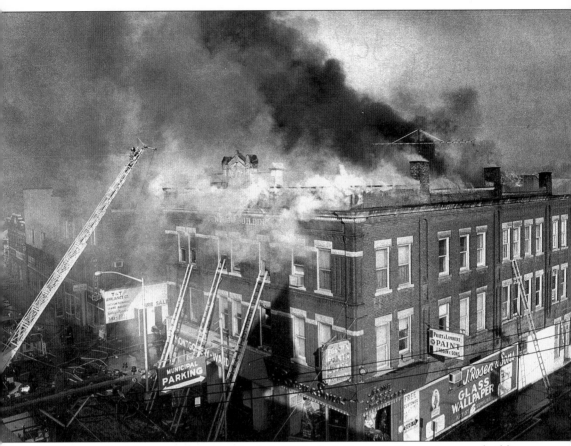

This was a hard fire to put out. On March 1, 1973, the J. Rosen & Sons paint store building, at North Street and Railroad Avenue, caught fire and burned for hours. The fire mushroomed into the cockloft below the roof and defied the firefighters. Shortly afterward the building was torn down, and the site is a parking lot today.

Seven

ENTERTAINMENT

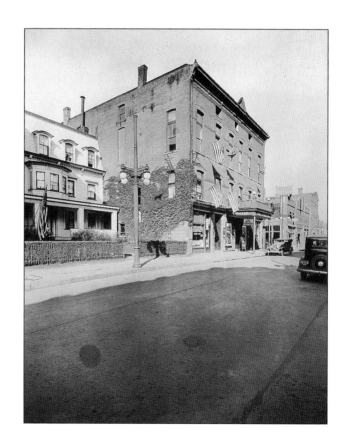

This is the Stratton Theater, on James Street, as it appeared on November 11, 1932. The buildings in the background still stand.

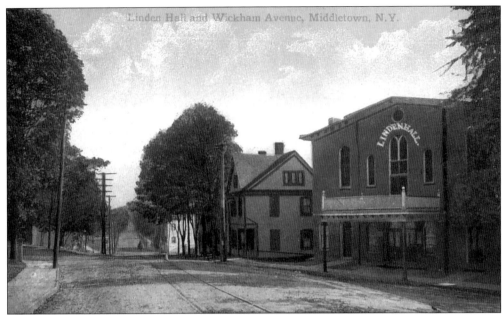

This view shows Wickham Avenue, with Linden Hall on the right. Linden Hall was the scene of numerous political rallies, meetings, and lectures.

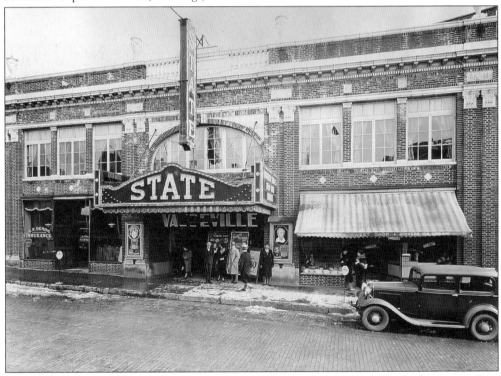

The State Theater stood on South Street opposite the Paramount. Vaudeville was still in fashion when this photograph was taken on March 2, 1933. Arthur R. Deming had his insurance office on one side, and a soda fountain and candy store occupied the other side of the building. The State closed on March 11, 1959, and the building was razed later that year.

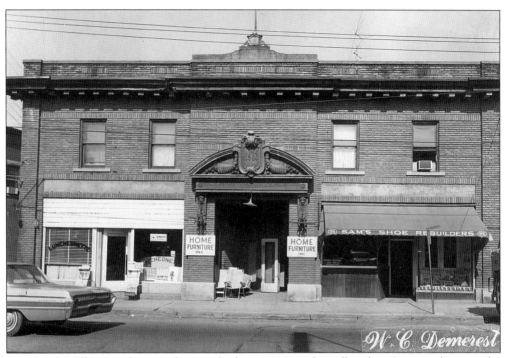

Another Middletown theater, this was built in 1913 as the Alhambra. Later, it became the Show Shop. Although vacant, the structure still stands at the corner of North and John Streets.

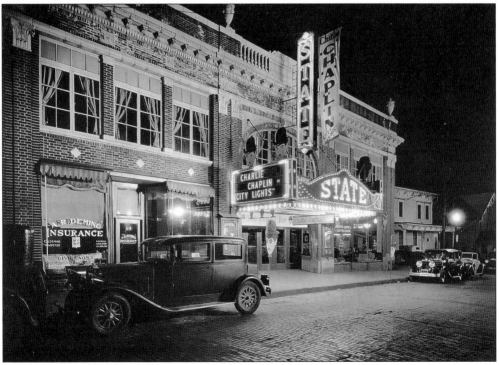

The film *City Lights*, with Charlie Chaplin, was playing at the State Theater on April 7, 1931, when this photograph was taken. Parking was already getting to be a problem.

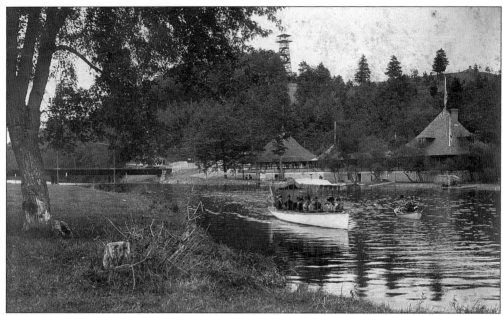

Midway Park, fondly remembered by a generation of old-timers, was a trolley amusement park located between Middletown and Goshen. This photograph shows a launch on the lake and pavilions. The famed roller coaster is not shown in this photograph. Many electric lines operated parks like this, accessible only by their trolley cars.

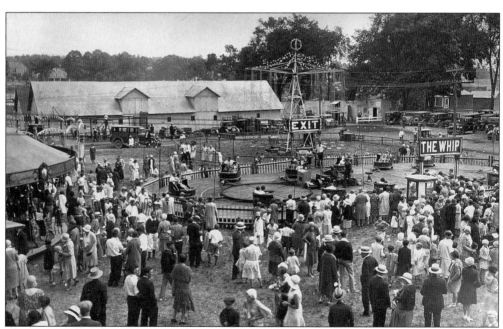

The Orange County Fair has long been a tradition in Middletown. The fair has been expanded greatly over the years since this late-1920s scene. Youngsters still enjoy the rides, though.

Eight

TRANSPORTATION

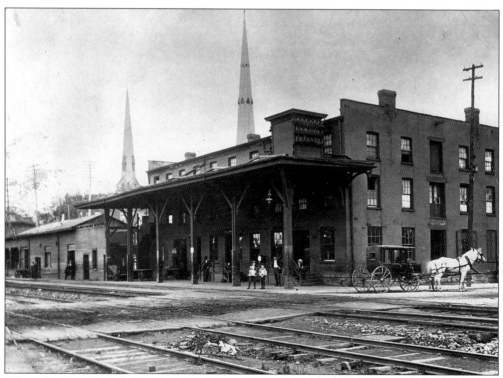

When the New York & Erie Rail Road was extended to Middletown in 1843, this station was built to serve the community. The building served the Erie until 1896 when a more modern depot was constructed on the same site.

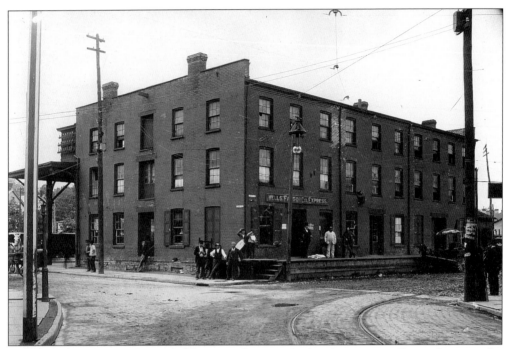

This seldom seen view shows Middletown's first Erie Railroad station, on Depot Street at the corner of James Street. The rails in foreground are trolley tracks.

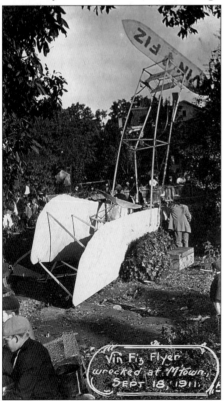

The Vin Fiz Flyer was an early attempt to fly an airplane across the country. The pilot, Calbraith P. Rodgers, had numerous mishaps but finally accomplished the nation's first transcontinental flight. Rodgers left Long Island and flew to Middletown on the first leg of his journey, following the tracks of the Erie Railroad. After landing at the Pleasure Grounds on Dolson Avenue, his takeoff the next morning resulted in a crash. The Erie baggage car served as a workshop and the plane was soon repaired. The date was September 18, 1911.

Calbraith P. Rodgers waits in front of the Erie station with his characteristic cigar while his aeroplane is being repaired. Rodgers succeeded in flying to California only to lose his life shortly afterward in a demonstration flight.

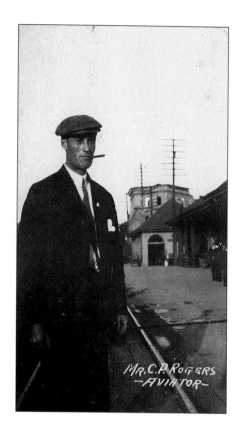

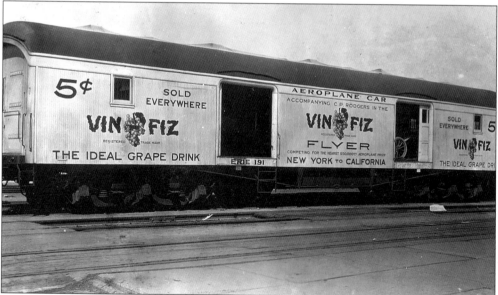

Erie Railroad baggage car No. 191 was Calbraith P. Rodgers's support vehicle, used as a workshop during the repair of the plane that crashed at Middletown. The car was painted a grape color so that it could be easily recognized from the air. The car accompanied Rodgers all the way to California.

Willard M. Gould began work for the Middletown-Goshen Traction Company in 1894, became superintendent in 1907, and rose to general manager in 1919. The name of the trolley line was changed to Wallkill Transit Company in 1907.

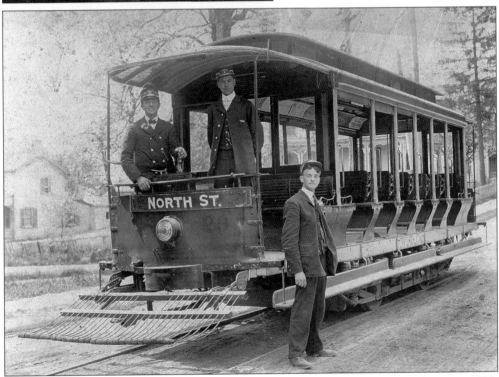

Open car No. 29 reaches the end of the line, at Academy Avenue and Genung Street in 1908. The motorman and conductor are aboard the car while Clarence Jacobs stands on the street.

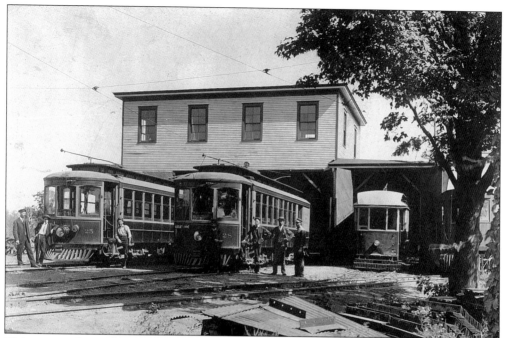

This picture shows three trolleys at the Mechanicstown carbarn in 1907. The two larger cars on the left were used for the run between Middletown and Goshen.

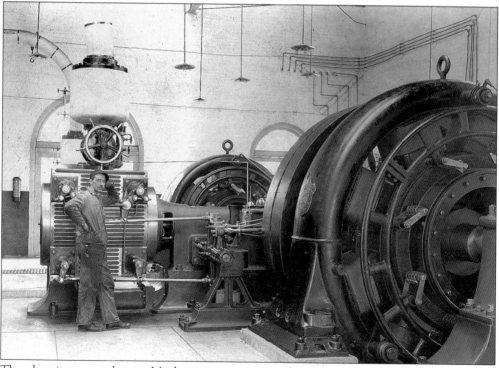

The electric power plant at Mechanicstown contained steam engines and massive generators that supplied the power for the Wallkill Transit Company's trolley cars. This building now houses the offices of the C.R. Wolfe Heating Company.

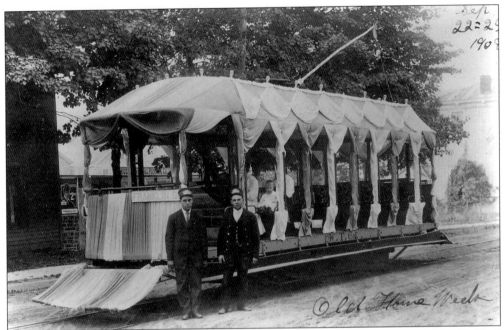

Decorated for Old Home Week of September 1908, this single-truck open car of the Wallkill Transit Company stands on Low Avenue.

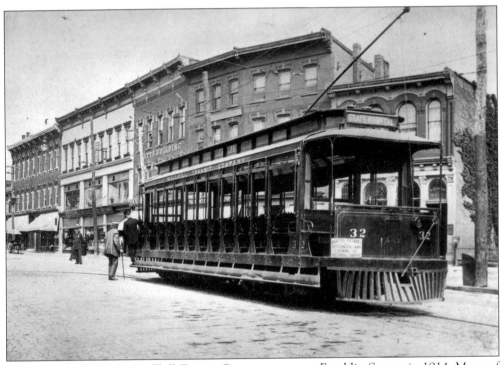

Open car No. 32 of the Wallkill Transit Company stops at Franklin Square in 1914. Many of the buildings in the background still stand. Streetcar companies maintained open cars for summer and closed cars for winter.

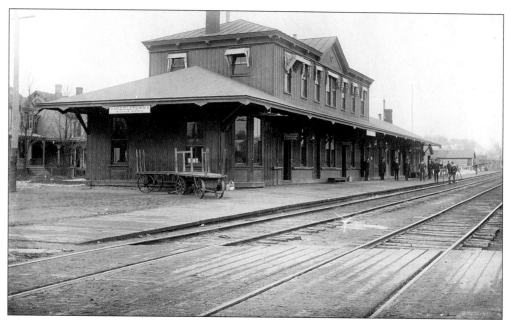

This was the New York, Ontario & Western Railway's Wickham Avenue station, before the present one was built in the same location.

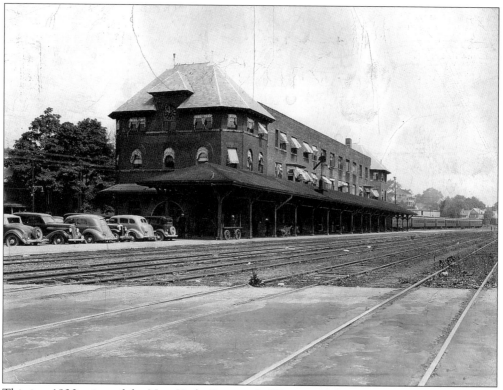

This is a 1930s view of the New York, Ontario & Western Railway's Middletown station and headquarters building. The building still stands today, bereft of its railroad, which ceased operations in 1957.

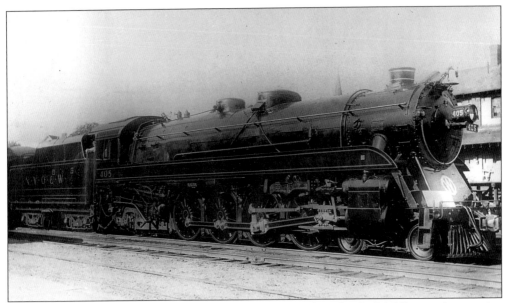

New York, Ontario & Western engine No. 405 was turned out by the Middletown locomotive shops in a livery of maroon, orange, and silver for the road's famed passenger train, the Mountaineer. The locomotive stands at the Wickham Avenue station in 1938. It was often run by engineer Pat Diver, who took this photograph.

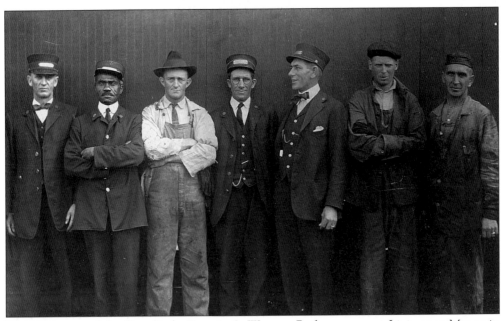

The train crew of the New York, Ontario & Western Railway poses at Livingston Manor in 1920 with train No. 22. Shown are Blake Merrit, conductor; Josh Baldwin, porter; Frank Knapp, baggage master; Phil Gross, trainman; Mike Hempstead, trainman; Guy Bennett, fireman; Pat Diver, engineer.

Nine

MILITARY

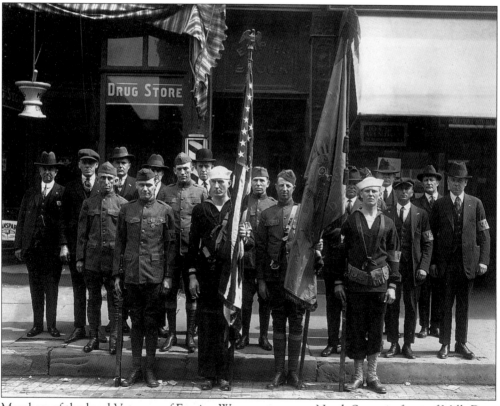

Members of the local Veterans of Foreign Wars post pose on North Street in front of Mills Drug Store shortly after World War I. They are as follows: (front row) Harry Decker, Leigh Adams, Silas Johnson, and an unidentified man; (middle row) George Bishop, Frank Smith, William Horn, C. Ellis Jones, Tony Casavetti, and Fred Dailey; (back row) William Bearns, Bus Warren, Fred Kniffen, James Levins, Albert Conkling, and William McElroy.

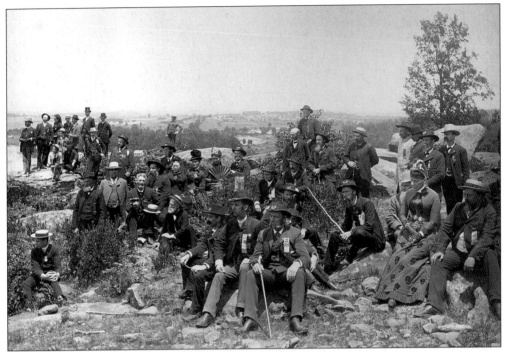

Veterans of the 124th New York Regiment, the famed "Orange Blossoms," pay a visit to Gettysburg, Pennsylvania, on July 1, 1888. All members of the group look solemn as they recall the place where so many of their comrades fell. Many of the men wear their campaign hats. Note the woman in the back spreading her fan.

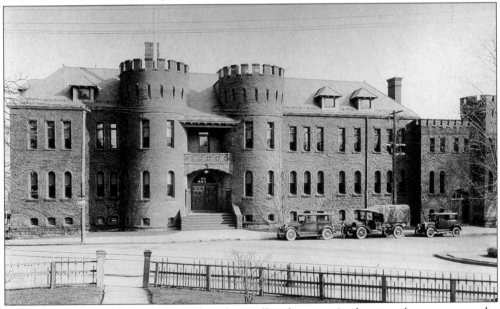

Middletown's State Armory was rebuilt with castellated turrets. At this time the armory was the home of the 24th Separate Company, New York National Guard. A number of additions were made to the original building, which had only one tower. The building remains today, but the crenels on the turrets have been removed.

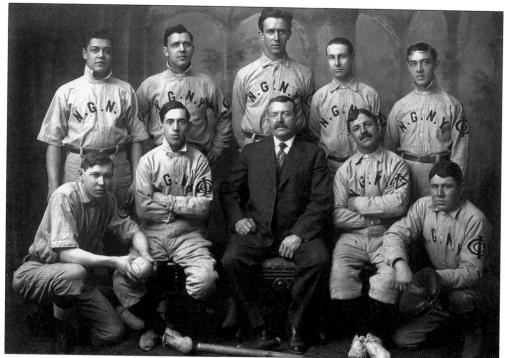

For many years indoor baseball was played in the drill room of Middletown's State Armory. This is the National Guard team of 1911. Shown are the following members of Company I, 1st Regiment, New York National Guard: (front row) Charles Paret, Bert Reeve, S.Sgt. Harry L. Steedman (manager), John Colwell, and Irving Wood; (back row) Clarence Cortright, Harmon Mentley, Cornelius Pickard, Oliver Hill, and Charles Ogden.

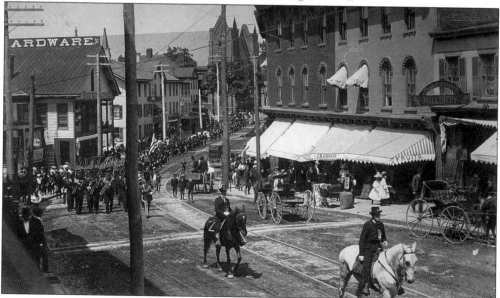

A parade winds its way up West Main Street toward Franklin Square. Military in appearance, the celebration may have been for the Grand Army of the Republic. When this 1890s photograph was taken, West Main Street had not yet been paved.

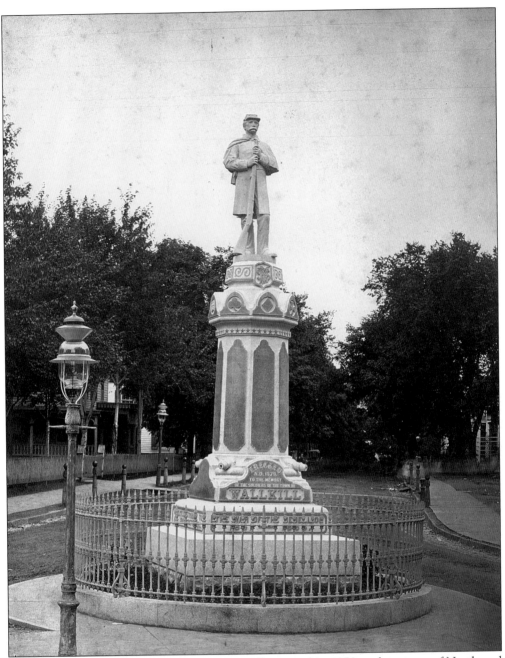

The Civil War Soldiers Monument was originally erected in 1879 at the corner of North and Orchard Streets. It was later moved to Thrall Park, where it stands today.

Ten

THE CLEMSONS

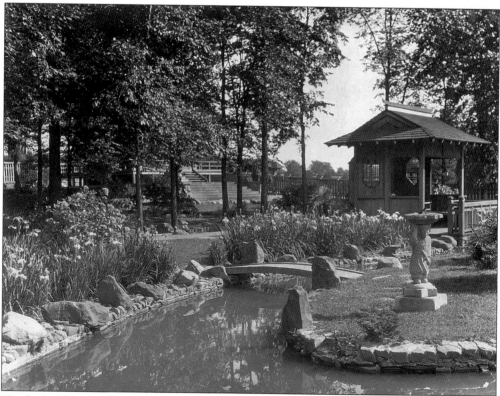

Elizabeth Clemson designed a beautiful Japanese garden on the Highland Avenue estate she and her husband, George N. Clemson, owned. Unfortunately, in 1966, the garden was removed and the various artifacts were sold at auction. The Japanese garden was one of the showplaces of Middletown and is fondly remembered by those who were privileged to visit it.

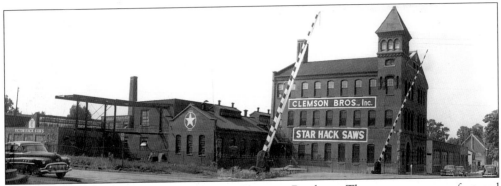

One of the city's foremost industries was Clemson Brothers. The company manufactured hacksaw blades under the trade names "Star" and "Victor." Clemson also produced a line of lawn mowers in a purpose-built plant across the street from the complex shown. Many of these buildings still exist, although the railroad crossing is now gone.

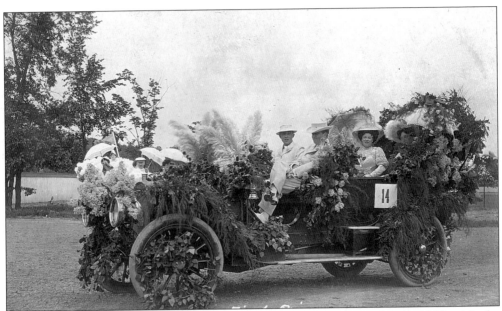

George N. Clemson sponsored the Grand Auto Carnival on September 7, 1907, with the proceeds going to Thrall Hospital. There were several prizes for the best-decorated cars. This large touring car, No. 14, won the first prize. According to a handbill on display at the Historical Society of Middletown, the carnival was held at Clemson's "private park on Highland Avenue."

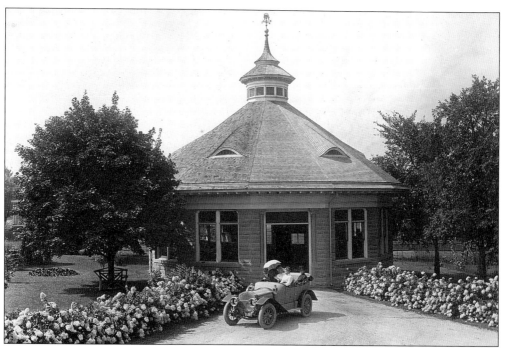

This circular building was on the Clemson estate, off Highland Avenue. It may have served as a garage.

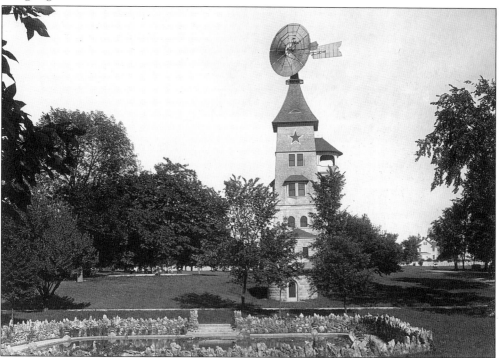

The Windmill Cottage was located on the Clemson estate. Note the star that is worked into the wall. The top of the windmill was visible from Commonwealth Avenue, the grounds at that point being enclosed with a wooden fence.

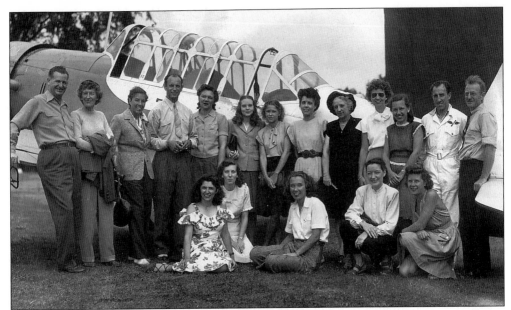

Mabel Clemson and the 99's, International Women Pilots, Metropolitan Chapter, are shown in front of a BT-13 aircraft at Starhaven Airport on August 3, 1946. The wife of Richard Clemson, she is the second from the left. The airport was located on today's Randall Heights.

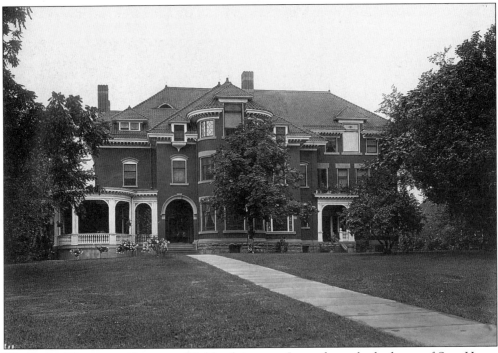

This is the Clemson residence, on Highland Avenue. It was formerly the home of Sen. Henry R. Low. Today, it is the site of the YMCA. The senator's name, which is often mispronounced, actually rhymes with "cow."

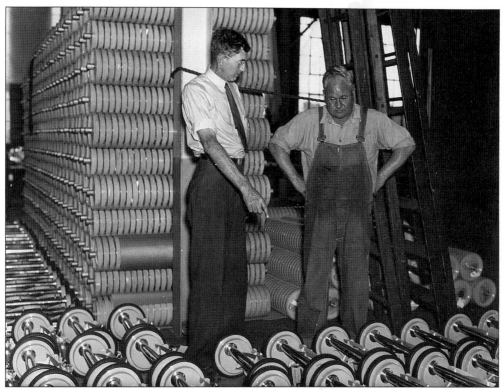

In the Clemson Lawn Mower plant, Walt Crist points to some partly assembled mowers as Peter Kelder looks down.

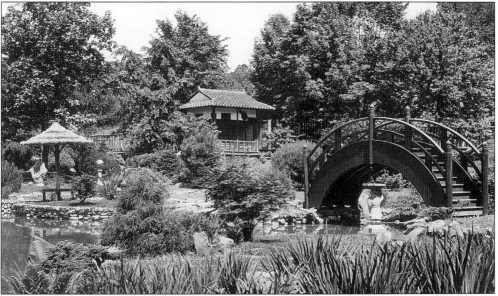

This is the Japanese garden on the Clemson estate. The garden was begun in 1913 by workers imported from Japan. The Moon Bridge reflects a round shape in the water. The ceremonial teahouse and other structures are exact copies of buildings that Elizabeth Clemson saw on a visit to the Orient in 1908.

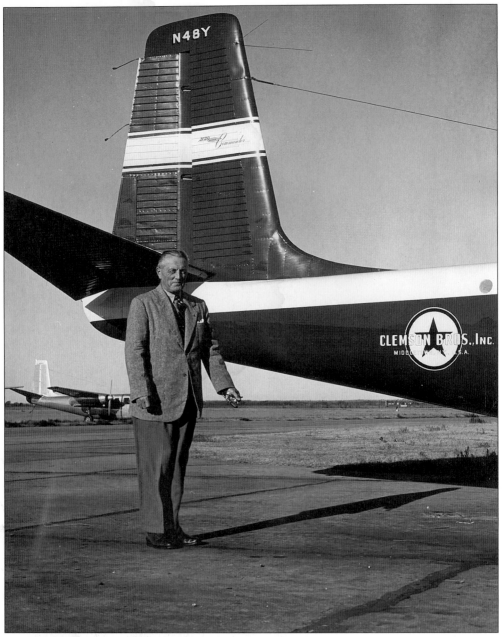

Richard D. Clemson poses in front of the company plane, an Aero Commander, in Oklahoma City, Oklahoma.